אני שלי / קסדרין

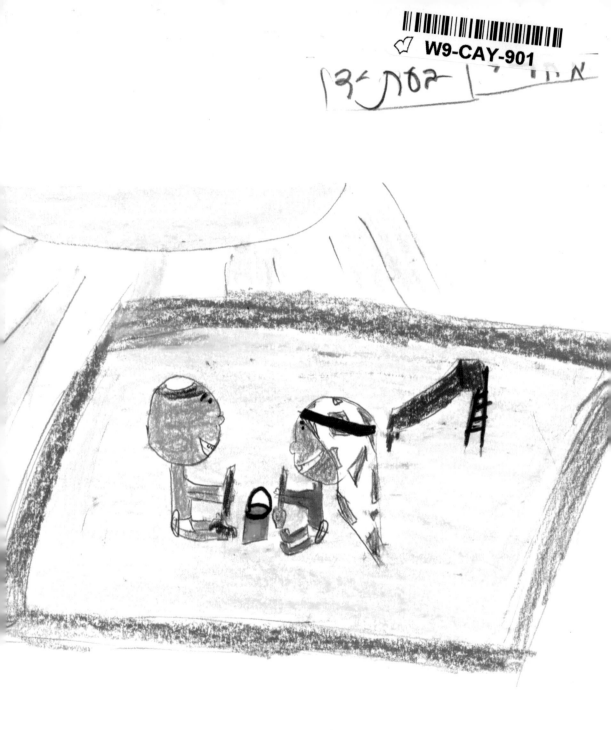

אורי שירצקין /

To Margot
who continues
to help children
believe they have
a future—

love
Dorothy

TURBULENT TIMES
PROPHETIC DREAMS

Art from Israeli and Palestinian Children

Harold S. Koplewicz, M.D.
Gail Furman, Ph.D.
and
Robin F. Goodman, Ph.D.

DEVORA PUBLISHING

All the proceeds of Harold Koplewicz and Robin Goodman
are being donated to the NYU Child Study Center
for the advancement of child mental health.

For more information about the NYU Child Study Center
visit www.AboutOurKids.org

All of Gail Furman's proceeds are being donated to
The Children in Armed Conflict
at the International Rescue Committee.

Published by DEVORA PUBLISHING
Text copyright © 2000 Harold Koplewicz, Gail Furman, Robin Goodman

Devora Publishing books may be purchased for educational
or special sales by contacting:
Devora Publishing
1-800-232-2931 Fax: 212-472-6257

Cover Design: Ben Gasner Studios
Design: Benjie Herskowitz

ISBN: 1-930143-09-5

Printed in Israel

Table of Contents

Foreword by Gail Furman 7

Guide For Children And Adults 10

Introduction by Harold Koplewicz
 and Robin Goodman 12

Lessons Learned 14

Art: Turbulent Times 15

Art: War/Peace 37

Art: Prophetic Dreams 49

In memory of
David Gorman

Acknowledgments

We would like to thank the following individuals, organizations and schools who worked diligently to make this book possible:

THE MIDDLE EAST CHILDREN ASSOCIATION (MECA) founded in 1996 by Dr. Ghassan Abdullah and Adina Shapiro. The mission of MECA is to safeguard the rights of all regional youth, regardless of religion or ethnic identity; to receive an enriching education in an atmosphere of tolerance and equality; and to promote cultural understanding, on a people-to-people basis, among Palestinians and Israelis.

ANAT SHVADRON (ATR, BFA)
Director of the adolescent unit of *The Jerusalem Center for Creative and Expressive Therapy.*

DEVORA GOTTHOLD-ZIPKIN (MPS, ATR)
Registered Creative Arts Psychotherapist. Supervisor for therapeutic and educational staff at the *Children's Wards of Hadassah Hospital, Jerusalem.*

YASSMINE SALAH (B.Ed Special Education)
Staff Member of the *Children's Wards of Hadassah Hospital, Jerusalem.*

Teachers of MECA: Fairouz Aboras, Wafa'a Misk, Oula Betune

Principals and students of the following schools:
Almalwaia School
Beit Hakerem School
Duvdevani School
Givat Gonen School
Mamad Harova School
Shuafat School
Yehudah Halevi School

Special thanks to Muhammed Hourani of the Hartman Institute for his assistance with translations.

FOREWORD

Gail Furman, Ph.D.

The pictures reproduced in this book are not great works of art. They are simple statements of the personal visions of Israeli and Palestinian children. The ordinary life experiences of these children have taken place in an extraordinary time: the recent years that diplomats and headline writers call "The Peace Process."

These pictures illustrate the same themes portrayed by children everywhere – hopes for growing up, hopes for becoming useful citizens, hopes for becoming fathers and mothers, hopes for seeing everyone living "happily ever after."

I believe these pictures are important. They should be tacked on the walls of rooms where Israeli and Palestinian negotiators meet to discuss how Jews and Arabs should share the land. These pictures would remind these elder statesmen that their children are the "clean slates" upon which the future of both sides must be written.

And who would dare twist the truth or change his mind if he knew that the prayers of his children were at stake?

These pictures were not gathered at random. They were done by boys and girls, both Israeli and Palestinian, living in Jerusalem. These children, ranging in age from 9 to 14 years, were asked by their teachers to draw pictures of how they envisioned their lives ten years into the future. Many children also revealed how they believed their country would look once peace took hold.

I have conducted similar drawing programs in scores of settings. These range from New York City's inner-city schools and the well-equipped classrooms of Manhattan's private schools to the thatch-roofed "school" huts of refugee children around the world. Displaced youngsters in Angola, Rwanda, Burma, Cambodia, and Kosovo have shared their drawings with me over the past few years, when I visited those countries as a member of delegations for the *Women's Commission for Refugee Women and Children* and the *International Rescue Committee*.

The aspirations – I prefer to call them "graphic hopes" – of the Israeli and Palestinian children whose drawings are included in this volume did not vary in any important way from the positive outlook of children everywhere. Their drawings have revealed to me, a child psychologist, that children the world over want the same things: secure families and homes, and a chance to grow up, to work, to have families, and to do things that will help others. These wishes are remarkably similar regardless of race, culture, religion, language, or the child's circumstance.

With all their exuberance of expression, these drawings hold profound truth. Children everywhere used the colored pencils and paper we gave them to communicate directly their hopes for their lives and their countries. Perhaps there is a

small, as yet undiscovered chromosome within each of us that craves a world of joyous harmony.

That does not mean that children are by nature Pollyannas. They're not. In fact, children – even those who have witnessed the greatest barbarities of our time – can and do recall their traumatic experiences in vivid detail. But they do it in their drawings with a matter-of-factness that is both disarming and chilling. They can tell us – and the children of Africa and Asia indeed have – that they can remember clearly what has happened to their families, how their parents have been murdered, how their sisters were raped, their older brothers abducted, their homes destroyed; and they can tell about their own frightening flights to safety.

But these same children, when given the opportunity to envision the future, allow that gene for hope to take over their minds and hands. Quite remarkably, they can keep the horrors of the past separated from their vision for the future. The pictures of the future produced by these children – whether sick or well, maimed or whole, nurtured by parents or orphaned – are, more often than not, filled with hope.

There is great spontaneity in the drawings within this book. That spontaneity, I would conjecture, stems from the fact that many children were being asked to visualize the future for the first time. To be asked about the future, from a child's perspective, must be a strange and wonderful experience, one that children must find extraordinarily liberating.

In my own drawing projects, I engage the children in conversation as well as praise their efforts. I want to hear them tell me what the figures in their pictures represent in their own minds. What the children say should be reassuring to everyone who works for peace, whether it is in the Middle East, Africa, Asia, Europe, or the Western Hemisphere.

While their memories as expressed in their quotes may possess images as stark and direct as Picasso's screaming *Guernica*, the most cherished desires of children have the quality that Chagall captured in his rapturous depictions of love – both realistic and dreamy.

I have worked with nearly one thousand children in refugee camps and orphanages. All were victims of and witnesses to wars and genocides: some as targets; others as unwilling participants, press-ganged into armies and rebel hands, often as young as 7 years of age. Like the children of modern-day Jerusalem, they know that life is dealt from an adult deck that holds both bad and good cards. When asked about the future, almost all look only for the good cards. It is their choice – and it is a profoundly important one.

What the children who have contributed pictures to this book are telling us is that we should take their advice very seriously. We should do nothing that will diminish the power of that gene for hope that these children, like most children, possess from birth.

Kept alive and nurtured well, that gene will empower these boys and girls to

grow up healthy and to both fulfill their individual dreams and work together toward the peace they all so fervently crave.

To keep that gene alive, we must all concentrate on the question, "Can you tell us what you see in the future?" If asked frequently enough, this question can change the world for the Israeli and Palestinian children who are represented in this book, as well as for children everywhere.

As you look at the drawings and read the words of the children, you will see that the graphic and verbal responses are direct and very moving expressions of a faith and a spirit that should speak to both our hearts and minds. Their simple illustrations should challenge us to reward their hopes and their dreams with the peace and security that all children deserve and need in order to flourish.

The drawings of the children differ. While each retains an individuality (like a fingerprint), they reflect the experience, culture, and drawing talent of that child. All the drawings, however, convey intensity, focus, and a clear wish to be heard and taken seriously.

In Angola, which I visited in 1996, almost all the children drew their pictures of the *future,* with UN troops somewhere on the paper, protecting them. On the Thai-Burma border, in 1997, many children could only envision a future after they returned to their country. They often were drew pictures with themselves in the foreground, as part of a liberation force taking back their country. Then, in the background, often depicted as a thought or boxed-in corner, was the future as the child envisioned it. Many children saw themselves working *their* land as farmers again; many others worked as doctors or teachers. The same themes were present for recent refugees from Kosovo.

As you will see in the drawings of Israeli and Palestinian children, children from both sides of the conflict often express identical hopes, concerns, and dreams. For example, almost all want meaningful lives for themselves. Many Israeli and Palestinian children envision sharing their land; some would like to show the other, or be shown, important and historic sites in their country; a few draw the leaders of their community arguing and talking, but accomplishing nothing.

I have been fortunate to work with and learn from so many of the world's children. I am struck by how open and honest children the world over are and how much they desire a better future. They must be given that chance. Our goal must be to help all children achieve their dreams.

GUIDE FOR CHILDREN AND ADULTS

We have organized the pictures into three sections:

Turbulent Times – revealing the children's perceptions of their everyday world

War/Peace – juxtaposing the potential for war with the prayer for peace

Prophetic Dreams – demonstrating the hope for a new reality for the children

The overall themes of the pictures are delineated below. Sometimes the themes are easy to spot; at other times they require a closer look. Next to each picture we have written the obvious theme found in the illustration, but as you will discover, there is much more to be found within the simple, yet revealing images drawn by these children.

TURBULENT TIMES – *Depiction of the Physical World*

Themes:

- **Homeland** – The actual physical environment is illustrated realistically, with considerable detail. One finds the turbulent days characterized by a lack of vegetation, gray skies, and brown rubble.

- **Destruction** – There is a constant message of destruction in these drawings. They tell us that conflict has lead to crumbling buildings, unsteady structures, parched earth, and lives that have been destroyed.

- **War** – We find that war intrudes in life, as shown by conventional but powerful images: blood, fearful faces, and dead bodies.

- **Protection** – Structures for safety are sought and found in places of worship or refuge. In times of strife, the walls of mosques or synagogues become places insuring physical safety rather than spiritual renewal, and the function of these structures as houses of faith is obscured.

Depiction of the Enemy

- **Competitors** – Each group commonly sees the other side as the aggressor. Blame and sorrow, however, are shared equally. Death and destruction are the only sure outcomes of war. And killing the enemy, both sides agree, is no solution at all.

- **Power** – Being more powerful than another person is shown to be an unrewarding and unworthy goal.

- **Conflict** – Individuals with specific names and meaning appear in the pictures of current times. The world of these children is colored by conflict and threatens those they love and depend upon. The message is clear: war is fought and felt in the hearts and minds of families, relatives, schoolmates, soldiers, and teachers.

Depiction of Feelings

- **Responsibility** – Individual children don't take obvious sides. Rather, responsibility for creating the problems and finding the solutions are seen as being in the hands of everyone – the adults and leaders on both sides.

- **Self-confidence** – Self-esteem remains intact for these young artists as they plan for their future.

- **Sadness** – The innocence of childhood has been lost for these children. Sadly, in many of the pictures, there is a lack of child-like joy and spontaneity.

- **Fear** – These children cannot be sure when or where they are truly safe.

PROPHETIC DREAMS – *Depiction of the Physical World*

Themes:

- **Growth** – In better times, the land is lush, with flowers growing, trees having firm roots, and birds flying skyward. Pastel colors dominate the scenes.

- **Construction** – In the preferred prophetic world, there is expansion and building; solid foundations replace the destruction of war. These are the underpinnings of new schoolhouses, markets – all aspects of a hoped-for life.

- **Peace** – When war ceases, battlefields return to their former domestic uses as farms and homes. Paths are built for peaceful interaction. Roads, bridges, and garden walks crisscross the scene, uniting different people from distant places. Strong and sturdy buildings reinforce the strong bonds laid down by peace.

- **Sanctuary** – Once again places of worship provide for safe expression of beliefs, they are no longer needed as fortresses. Symbols of peace are frequent: doves, temples, the old wall, and hearts.

Depiction of the Enemy

- **Brotherhood** – The children identify with people as individuals rather than with a group. In times of peace, dress shows ethnic difference rather than armaments of war. In this world, different individuals are bestowed with equal value and purpose. Figures stand close together and meet in friendship rather than in battle.

- **Cooperation** – True power rests with leaders who create peace, not war.

Depiction of Feelings

- **Responsibility** – The children see themselves as part of one nation. They see their mission as contributing positively to society.

- **Self-confidence** – In peacetime the children reveal their strength, their resilience and confidence in their ability to control destiny and achieve peace.

- **Happiness** – A child's simple desires are able to take flight in peace time – warmth of the sun, a home, the ability to play without fear, and the luxury of having imagined peace and real peace at the same time.

- **Security** – In a peaceful world the children trust adults, feel safe and secure, and no longer need strong walls to protect them from outside destructive forces.

INTRODUCTION

Harold S. Koplewicz, M.D.
Robin F. Goodman, Ph.D., A.T.R.-BC

It may seem puzzling to have mental health professionals from another part of the world involved in a book about the lives of Palestinian and Israeli children. As clinicians, we spend our professional lives listening to children. Unfortunately, some adults are too busy to hear children and some are dismissive: after all kids are just kids. Nevertheless, the feelings, words, and images that these Israeli and Palestinian youngsters express need to be heeded by the leaders of the Middle East and by adults everywhere who care about children.

Children have provided us with images of war and destruction as they experience it in their daily lives and, more importantly, images of real peace as it could be in the near or distant future. Contemplating the children's art in this book and hearing their pleas, we imagine them to be shaking their heads, wondering why it is taking so long to achieve something so simple and yet so important: people safely living together.

None of the children who made these drawings experienced any personal tragedy; neither they nor any member of their immediate families was physically hurt. However, they do live with day-to-day exposure, to threats, and news of war and casualties. Even so, most are optimistic. The children were asked to draw their region's current situation and their visions of the future. It is noteworthy that while the overwhelming majority drew peaceable scenes for the future with Palestinians and Israelis living in harmony, the present condition is illustrated as hostile and, in some instances, as full-fledged war.

We have tried to organize the drawings and words of the children in a format that will help readers to see the many meanings and implications of the work presented. In order for the messages contained in the art to be understood, we suggest different approaches for children and adults. For children, we offer specific key works on various pages to use as stepping-stones to further discussion. After reading the words, alone or with an adult, we hope that the children will imagine what life is like for the Israeli and Palestinian children and develop their own questions and answers about why people fight and how they can live together. We hope the adult readers will consider our fuller explanation of the thematic words as a guide to understanding the children's words and art.

ABOUT THE CONFLICT, ABOUT THE ART

Adults can be in awe of children's art; impressed by its directness, honesty, and naivete. This work can be viewed as documentation of events at a particular time in history. But what is most striking is the simultaneous ability of these drawings to provide insight into how the children make sense of their personal and political situation.

Looking at the art of the children, we have a chance to see not only specific landscapes but also witness talent, development, personality, coping strategies, and life circumstances.

The drawings made by these Israeli and Palestinian children and the accompanying words offer us a glimpse into how and what children subjected to conflict are thinking. These children seem to realize that the world is not always safe. For Palestinian and Israeli children, who grow up with visible, on-going conflict and tension, one wonders if and how they will negotiate between belief in a bright future and acknowledgment of everyday reality. Many of the children place blame for their unresolved turmoil on their own political leaders – the adults who govern their land. Some children give frank advice for changing the course of history, with the clear belief that it can change. Most of them reveal a resilience and optimism that is both surprising and inspiring, given the harsh environment in which they live. The 9 to 14 year old children who made these drawings have things in common with children everywhere. They want what all children want: education, family, security, peace and predictability.

Intellectually, children at this age have a firm grasp on reality, yet are at the same time able to use their imaginations. They can entertain ideas that are not necessarily plausible, but which indulge the mid-childhood and early adolescence luxury of believing that anything is possible. One is reminded of the moment in the film *E.T.* when the hero pedals his bike faster and faster until he is lifted up into the air. The transformation requires a suspension of belief. School-age children know it is impossible to ride off into the sky, at least on bicycles; but children at this age are equally determined to believe in the power of human effort to overcome obstacles.

Another characteristic of children in latency and early adolescence is their attention to the world around them. This coexists with their egocentric view of life. They are acutely aware of the size, shape and color of the things in the natural world and have increasing dexterity with which to depict these details in a drawing. Kids of this age are equally aware of differences among peers and in the environments they inhabit. They perceive the nuances of social relationships: of how people think, look and act. When drawing, children are given the opportunity to consider another's point of view. Yet, in beginning to consider the world beyond themselves, their innate self-centeredness may lead them, innocently, to believe everyone must feel just as they do. At times this is a strength, as it allows them to believe and hope that everyone is equally committed to the goal of peace.

As clinicians, these children's life circumstances inevitably prompt us to consider the symptoms of Posttraumatic Stress Disorder (PTSD), a syndrome first recognized in veterans of the Vietnam War. The disorder can occur when someone experiences or witnesses a one time event or chronic series of events that threaten or expose him to death, injury, or destruction of his surroundings. While it is impossible to diagnose anyone without direct examination, and these drawings were never intended to be diagnostic, we are able to note the striking optimism revealed amidst the existing threats. The artwork of *Turbulent Times Prophetic Dreams* demonstrates once again, in spite of the odds, how resilient and hopeful children can be.

LESSONS LEARNED

In America we feel confident and distant from the battles and prejudices plaguing the Middle East. Although we have been spared the experience of war for a generation or two, there are important lessons to be learned from these Israeli and Palestinian children. This work should propel us to focus on the effect of war on children, especially those in the Middle East, where generations have faced constant uncertainty and have come to expect turbulence. Even without a declared war, in our nation we must cope with youth violence, racial tension, and poverty which affects the children living in these environments. There are two messages and lessons offered by this artwork. First, that children faced with such conflict come to realize that the adults they looked to for safety are limited in controlling the larger world around them. The second lesson is for adults. The children are indeed holding us responsible to fix what is wrong and create a safe future with peace and brotherhood among neighbors.

Children are not immune to what they see and hear around them; it teaches them what to expect. There is a window of time when optimism about their future can survive the realities around them. Before that optimism is lost; before they become cynical, it is our responsibility to act. For parents, for citizens, for world leaders, the message is loud and clear. Children ask us to cooperate for the sake of their security.

Children's dreams require peace and in their pictures, the Israeli and Palestinian children have provided a visual map to that peace. According to these children, living with the threat of guns and tanks and weapons of destruction is not a viable answer. They are entrusting their future to the adult leaders of their nations, instructing them to lay differences aside with the mandate to live together.

Their pictures tell of turmoil in the present and of a much sought-after peaceful future. Our political leaders have the important task of finding the solutions and making the compromises that will end conflict. The hard work is left to adults, as it should be. Our children should not grow up to find that we have left them a legacy of unrest. The children themselves seem assured to succeed if we fail. However, we have nothing to lose and everything to gain by meeting their challenge.

TURBULENT TIMES

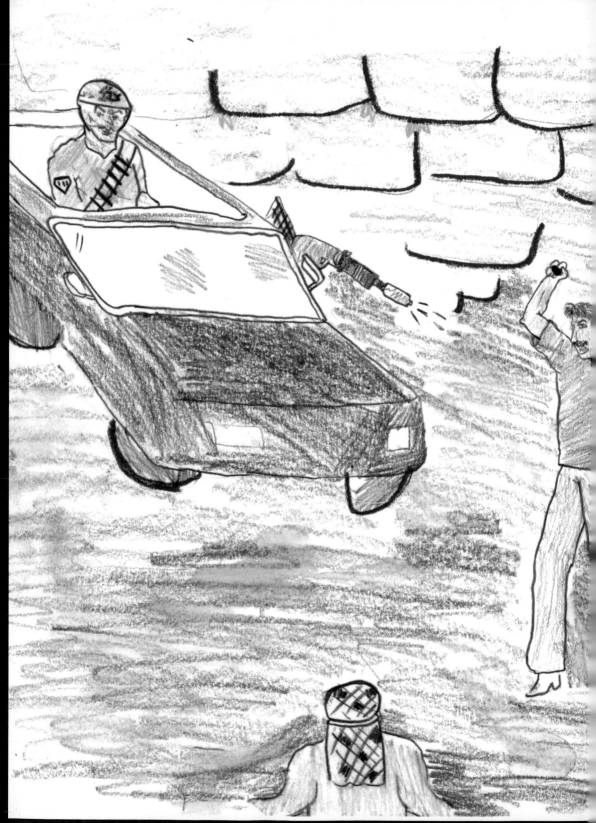

TITLE: **THE WAR OF NATIONS**

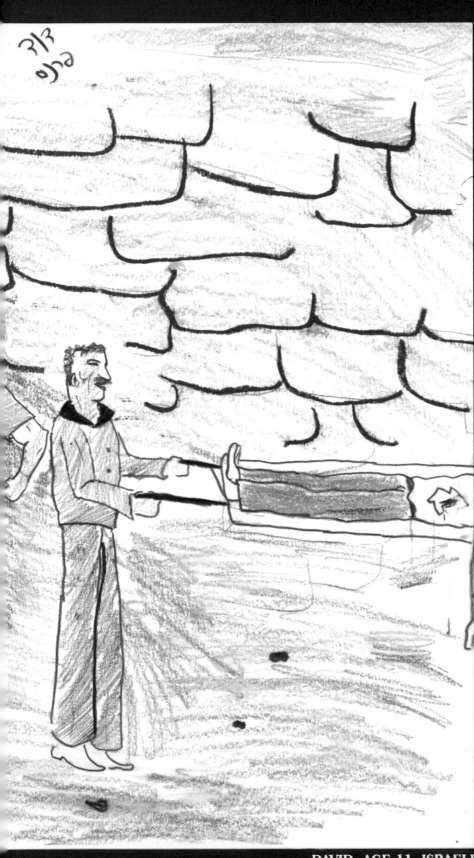

"The Palestinians throw stones at us and we shoot at them. This must stop if there is to be peace between us. We are fighting over symbols but people are being killed. Neither side seems ready to stop, but they must stop or else the only thing that will be left is the symbols."

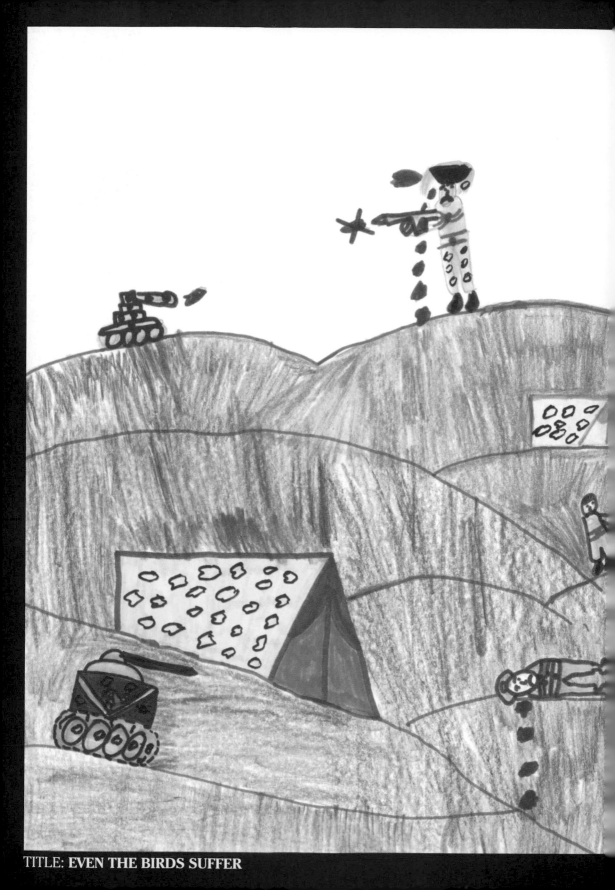

TITLE: **EVEN THE BIRDS SUFFER**

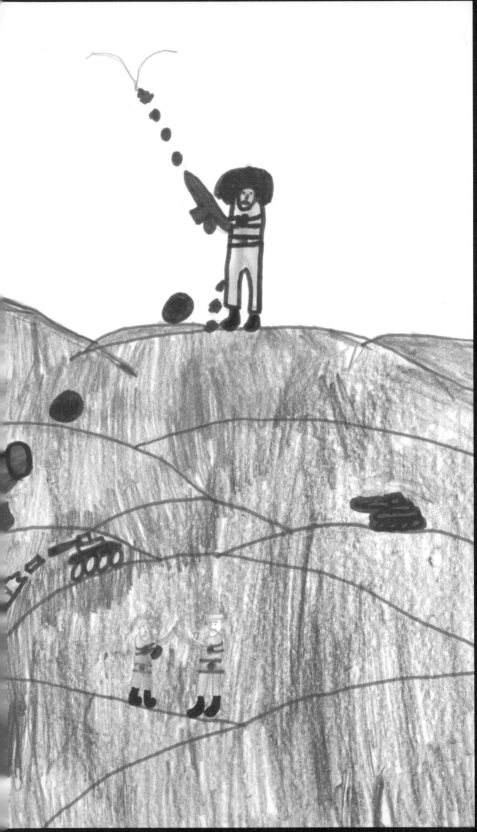

"Arabs fighting against each other will only cause more terrible problems in the Middle East. Soon everyone is fighting everyone else and the war will go on forever."

JULLIA, AGE 10, PALESTINIAN

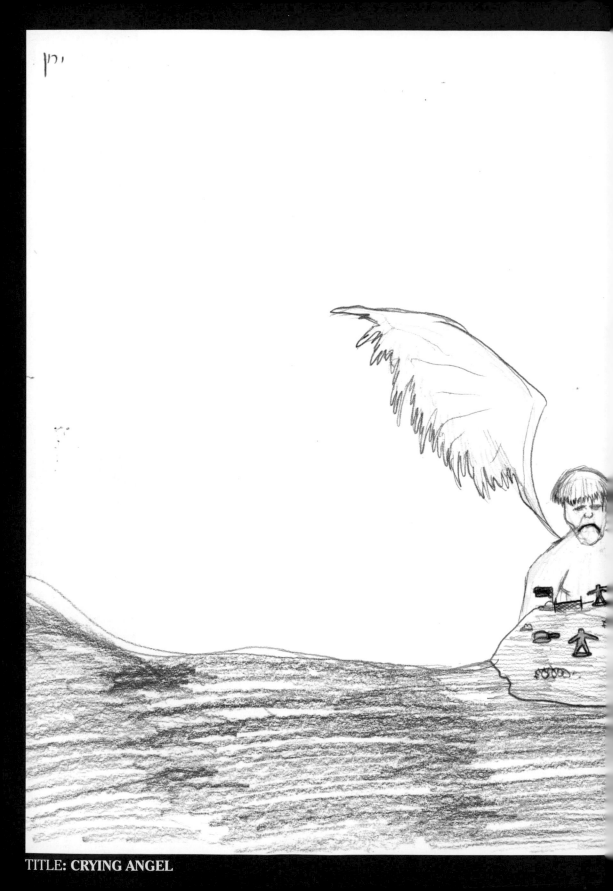

יין

TITLE: **CRYING ANGEL**

"After a terrorist act I get very angry that people kill innocent people. The terrorists believe that it is good to kill others and commit suicide and go to heaven, but meanwhile they destroy the world. If they want a better world, why do they make our world worse? I believe we will reach an agreement. The whole world will come to understand that it is better to compromise and I think the future will be better."

YARON, AGE 12, ISRAELI

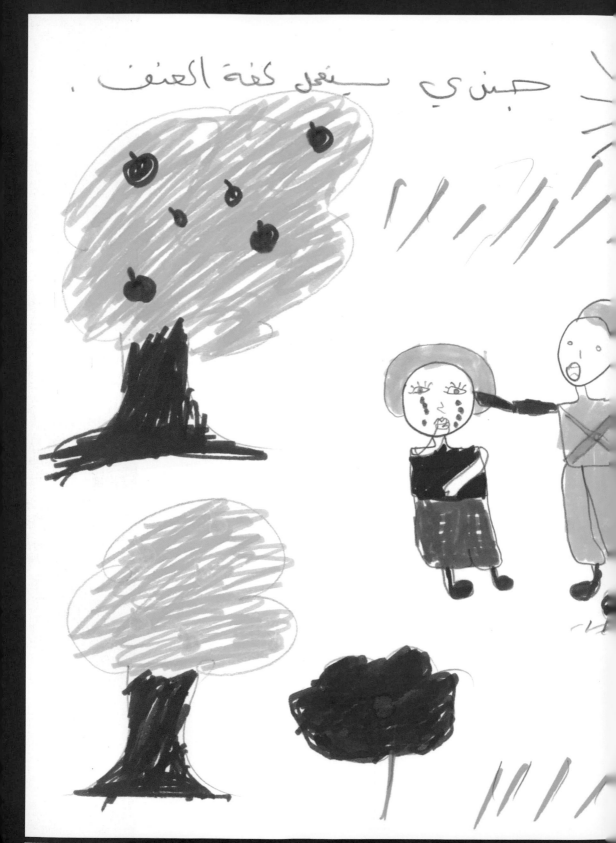

TITLE: **SOLDIER PORTRAYING THE LANGUAGE OF VIOLENCE**

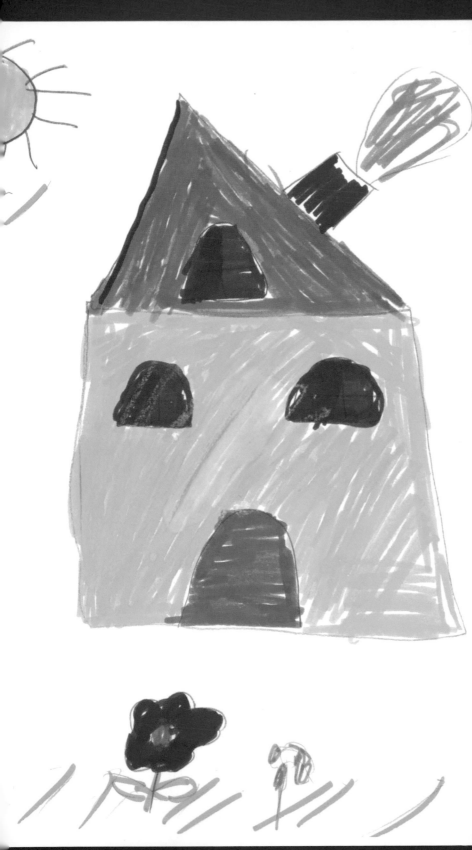

"We don't know what will happen in the future because the Palestinians are in conflict and the Jews are in conflict, and this will cause difficulties between both groups. I want peace but when I see the soldiers on television hitting the Palestinians, I can't believe it."

JARAH, AGE 11, PALESTINIAN

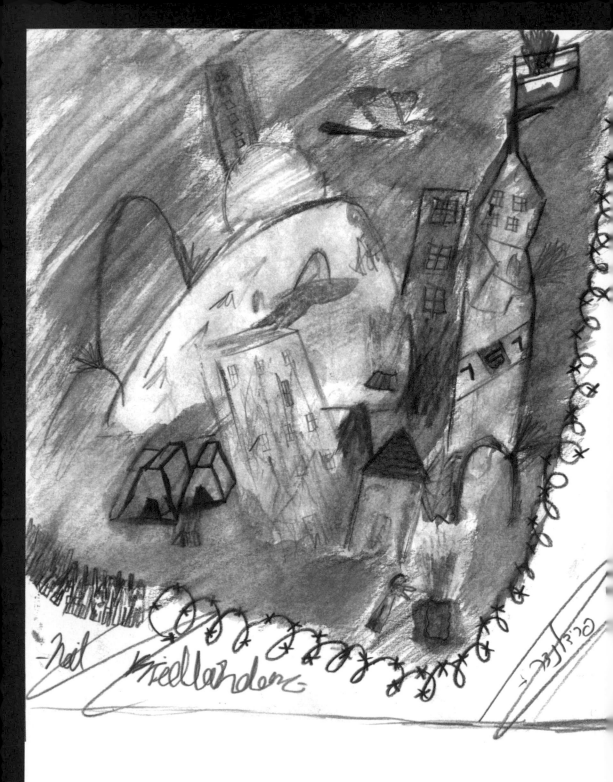

TITLE: **WHY RUIN OUR LIVES?**

Destruction

"I think about the situation in Israel and worry about the Palestinians as well. They have families too. I don't want the disaster in this picture to happen to me or them. But how can we stop it?"

NEIL, AGE 9, ISRAELI

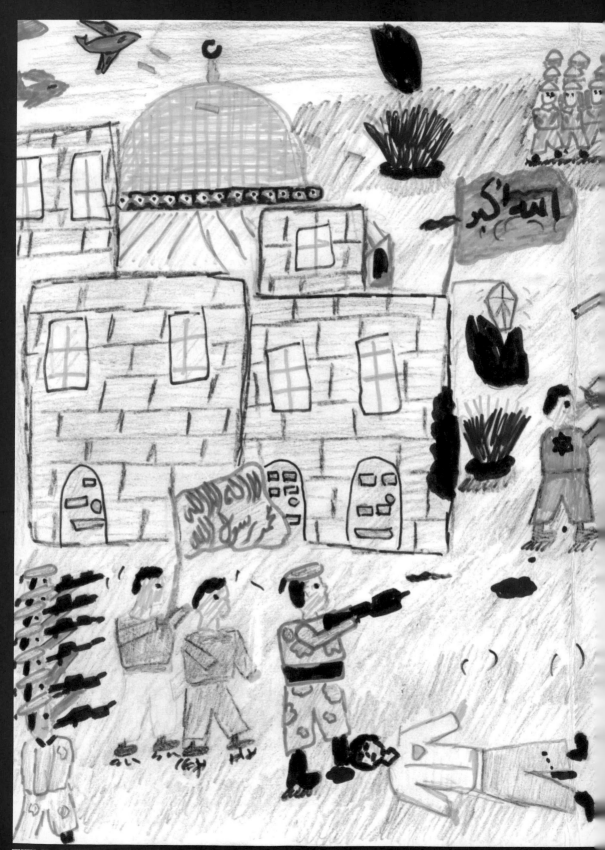

TITLE: **JERUSALEM WILL NOT BE OCCUPIED FOREVER**

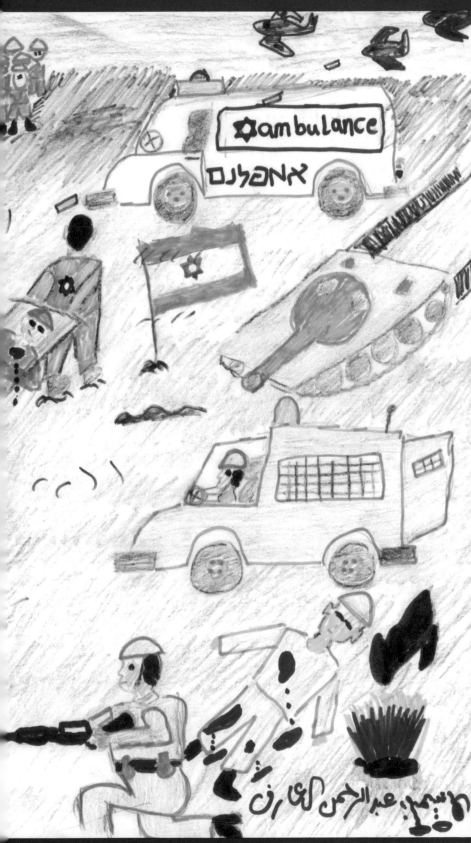

"This is the final war between Arabs and Israelis, but Jerusalem is freed. The Palestinian Army has guns and is fighting the Israeli Army. But the Israeli Army has tanks."

ABDUL, AGE 10, PALESTINIAN

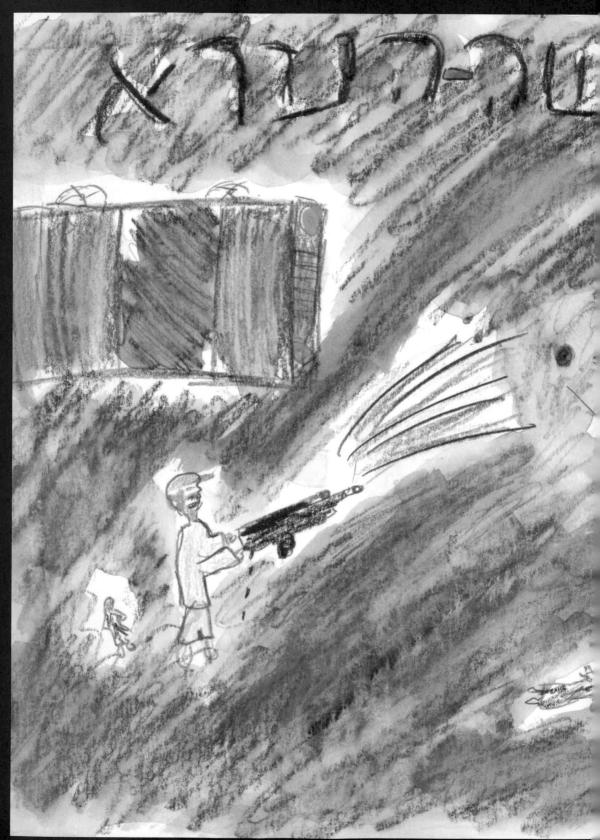

TITLE: **THE HORRIBLE DEED**

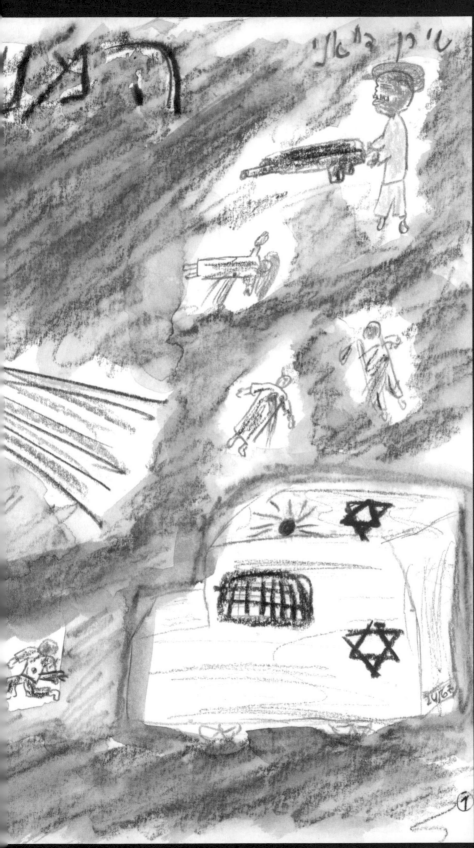

"I believe that when there will be peace we can be friends with Arab children and trust them, but as long as there isn't peace I don't trust them, maybe they have bad intentions. I think it's the children who should convince their parents to make the peace treaty."

SHIRAN, AGE 11, ISRAELI

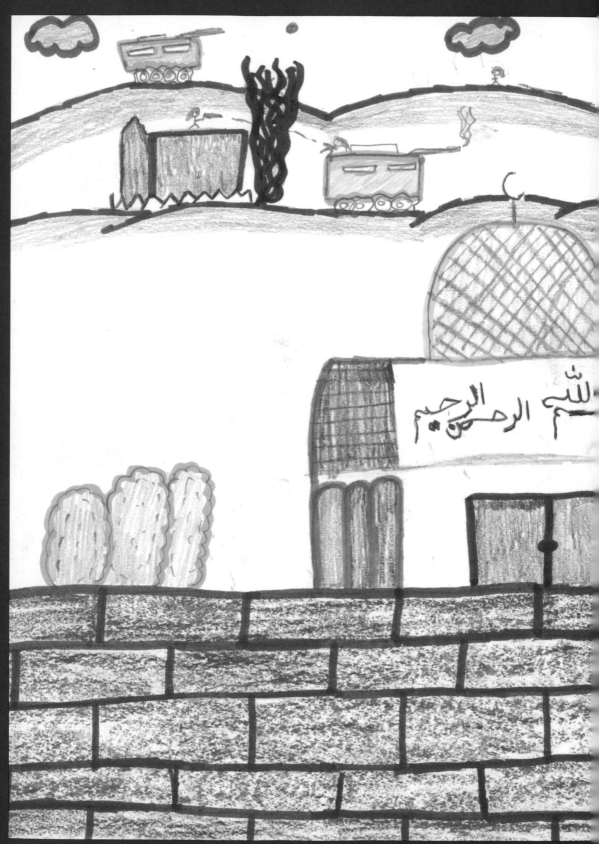

TITLE: **IN THE NAME OF THE MERCIFUL GOD** *(This is the first verse of every section of th*

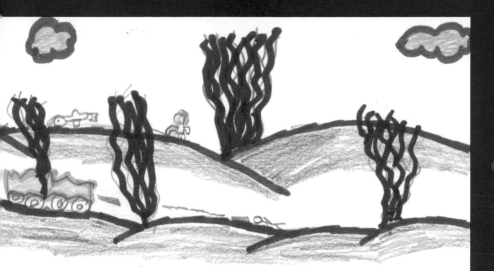

"Violence is what happens between Jews and Arabs when both sides want to rule Jerusalem. Today, each side waits for the other to go to their house of worship and then attacks. In the future, the fighting will be behind them and both sides will be able to pray peacefully."

CHEMDI, AGE 13, PALESTINIAN

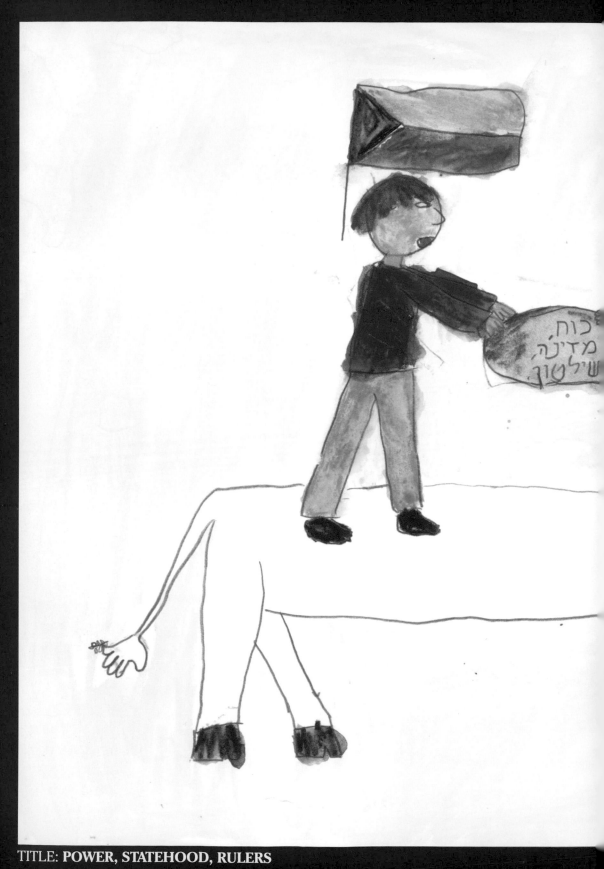

TITLE: **POWER, STATEHOOD, RULERS**

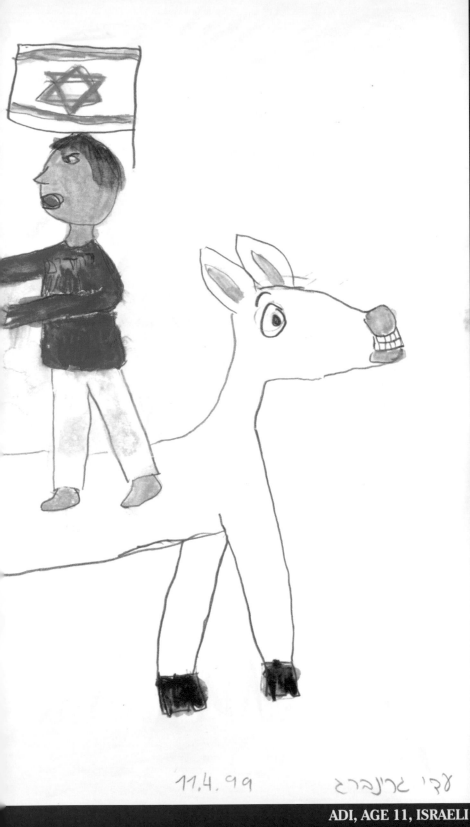

11.4.99

אדי שולברג

"*Everyone is waiting for the Messiah to come along on a white donkey, but when he comes all he will find is Israelis and Palestinians fighting with each other. Is this the future we want?*"

"*It is not the people who are angry with each other, it is the leaders. The leaders are like the messiahs only instead of bringing peace they bring conflict wherever they go.*"

ADI, AGE 11, ISRAELI 33

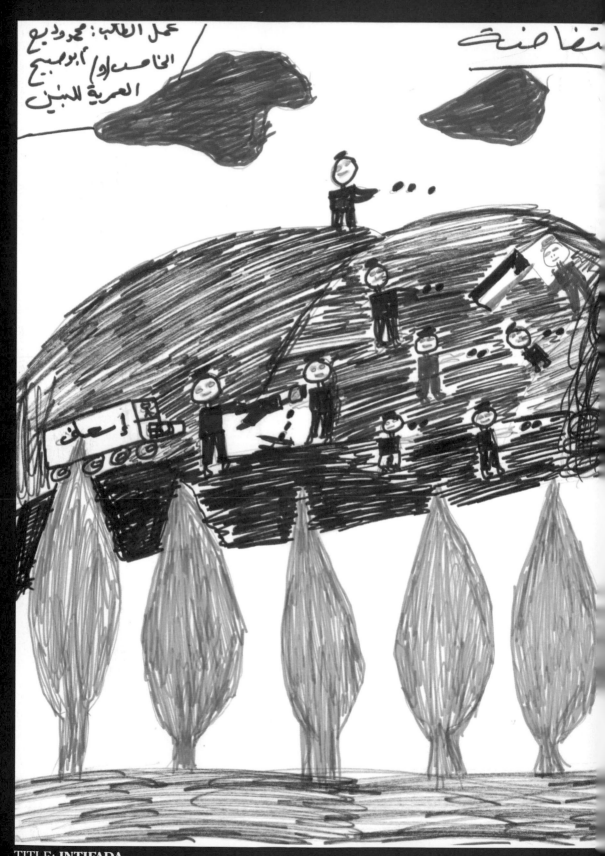

TITLE: **INTIFADA**

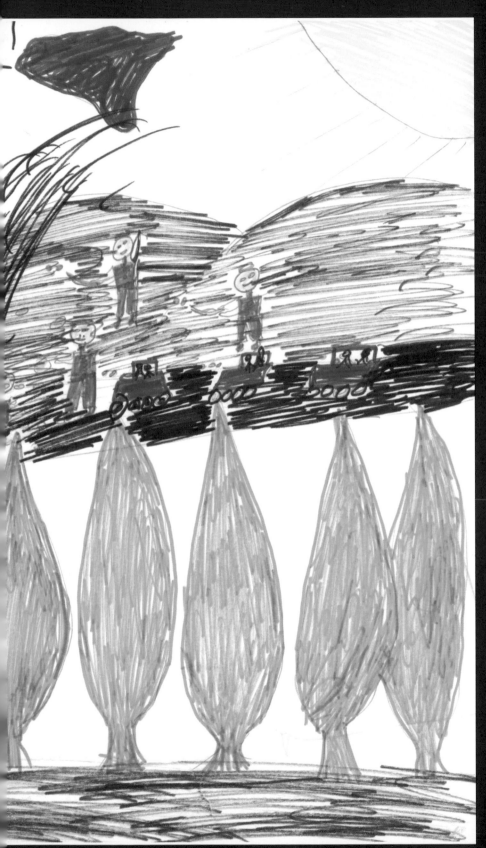

"Young people fight in order to protect their homeland. My picture is about young people dying as they fight against the Jewish people. Palestinians are using stones and swords against the Israelis. In the future, the land will be ours and the trees will bloom."

MOHAMED, AGE 11, PALESTINIAN 35

WAR
PEACE

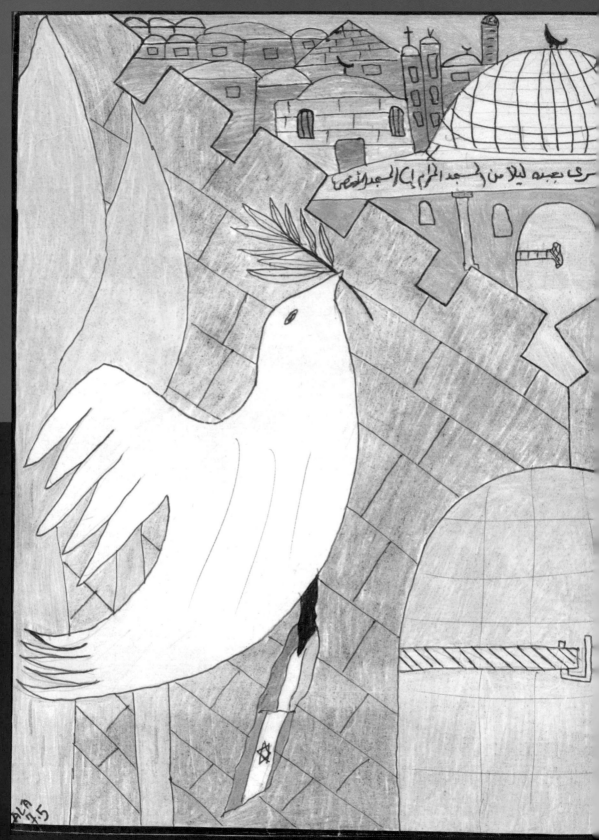

TITLE: **FROM MECCA TO AL AKSA**

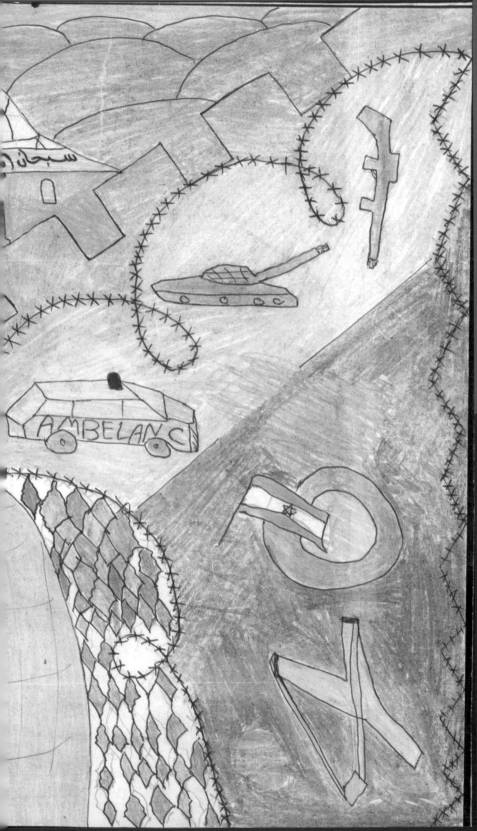

"I give thanks for the words of the Koran that say, Thank God Who took His servant from Mecca to the Far Mosque, Al Aksa."

"We must overcome all obstacles to reach our goals and keep our holy sites. Yet if there is a call for peace from the Israelis, we must be willing to listen to this too."

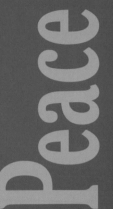

War

MOHAMMED, AGE 12, PALESTINIAN

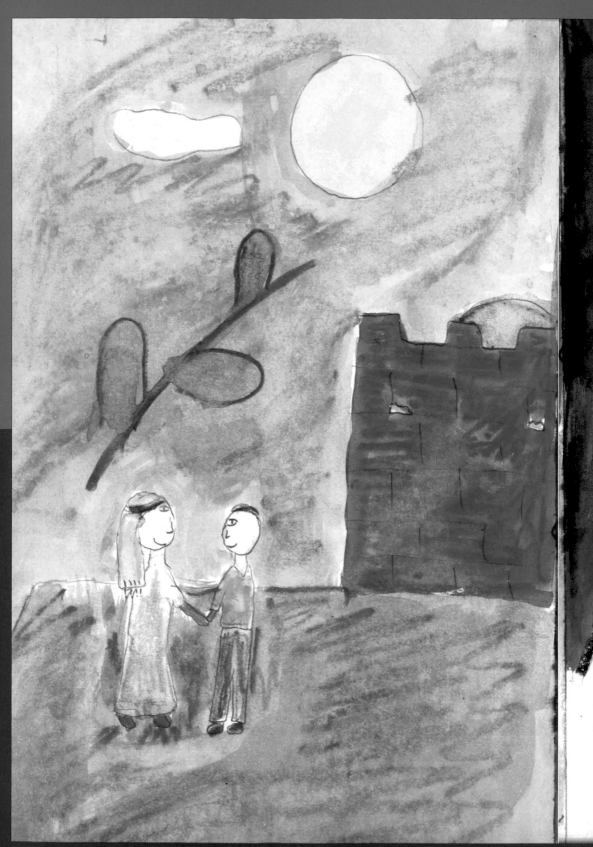

TITLE: **PEACE OR DEATH: THE CHOICE IS OURS**

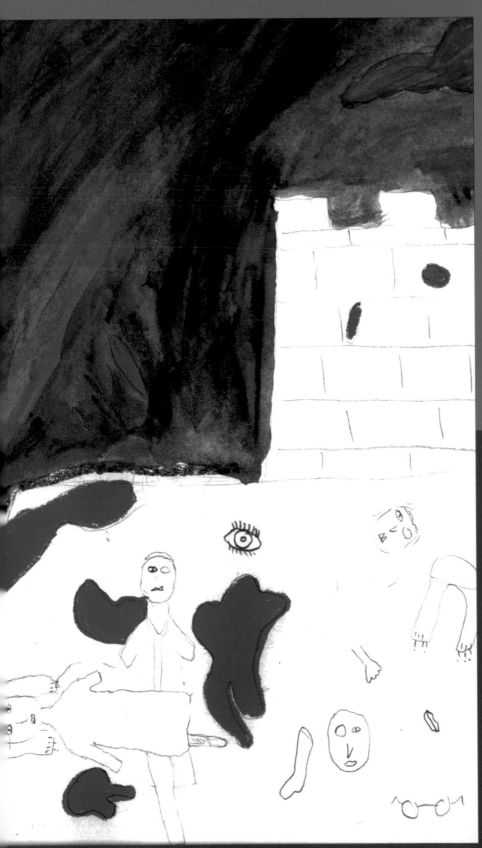

"Acts of terror hurt me. An act of terror could happen against one of my friends or a relative. It hurts me also when violence is done because of racism. I feel the pain for those killed and their families. I understand the Arabs wanting their own State, but they go way too far in the way they go about reaching their goal. We all need to compromise to reach peace."

War

ORIANE, AGE 11, ISRAELI

41

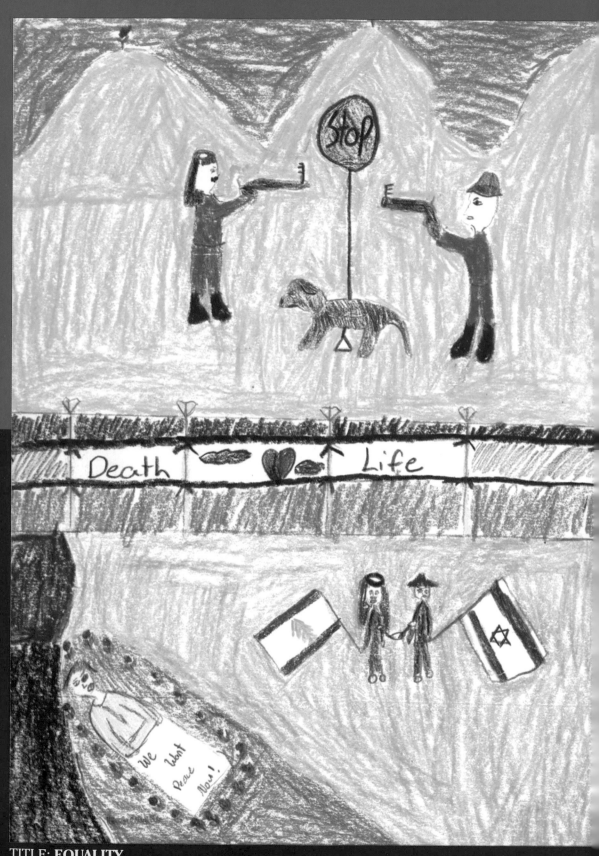

TITLE: **EQUALITY**

"I believe that the situation will continue as it is. The reason there will be no peace is that neither Israelis nor Palestinians are willing to give in and prefer to remain stubborn. We attack them and they attack us. I feel terrible when people say the Palestinians are bad. It is not right that they kill us and it is not right that we kill them. When will it stop?

War

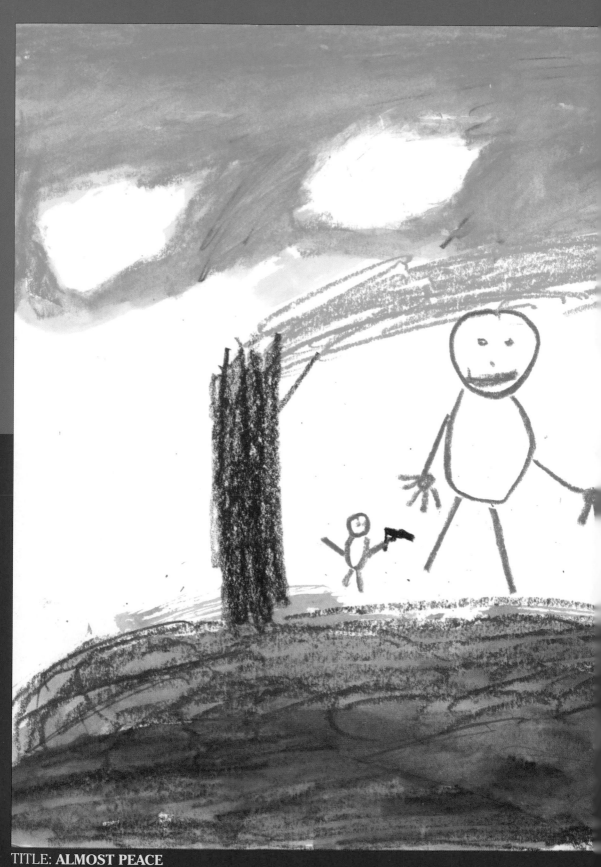

TITLE: **ALMOST PEACE**

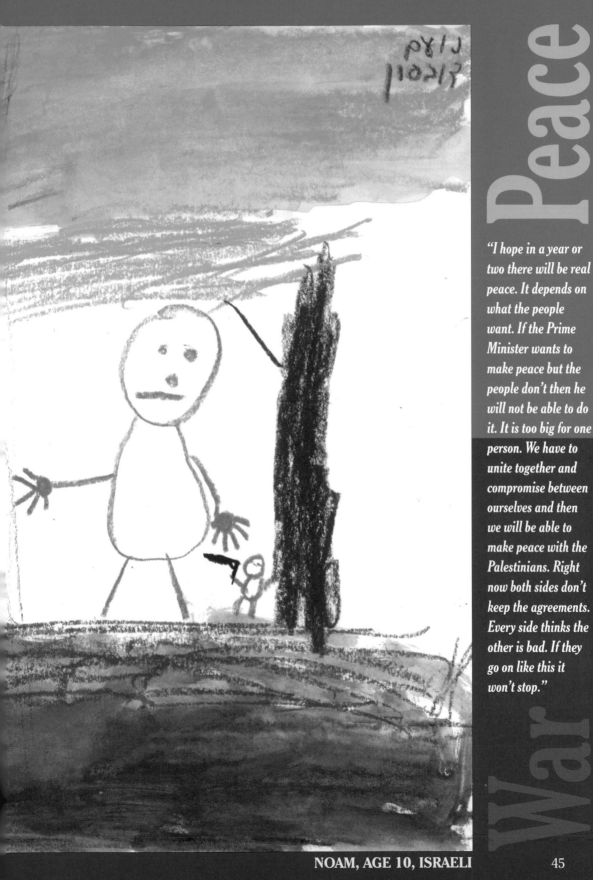

"I hope in a year or two there will be real peace. It depends on what the people want. If the Prime Minister wants to make peace but the people don't then he will not be able to do it. It is too big for one person. We have to unite together and compromise between ourselves and then we will be able to make peace with the Palestinians. Right now both sides don't keep the agreements. Every side thinks the other is bad. If they go on like this it won't stop."

War

NOAM, AGE 10, ISRAELI

45

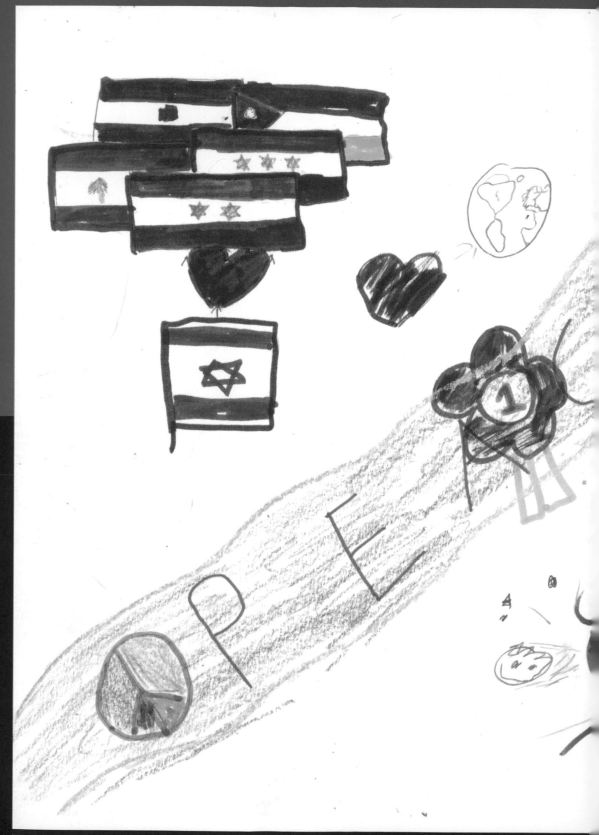

TITLE: **LOVE CAN OVERCOME WAR AND DEATH**

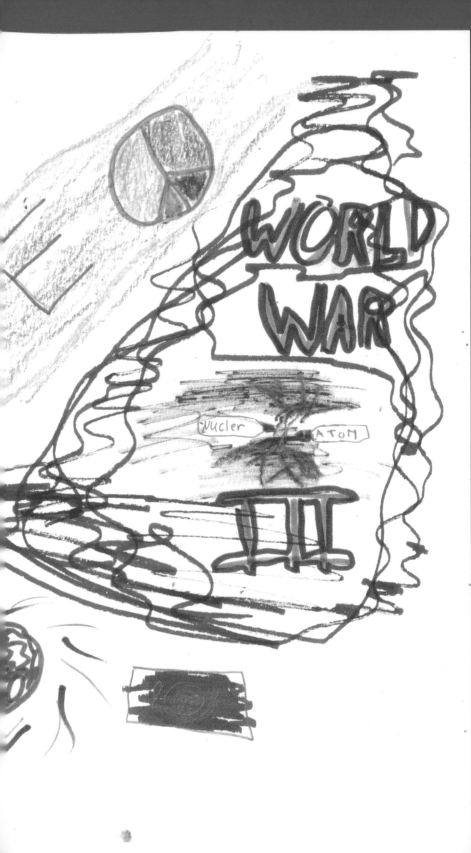

"We won't have many chances to stop the world from being destroyed. We need to show our love for each other, not how much armament we have. All the Arab nations and the Israelis must create peace or the next World War may come from the Middle East. If it comes, the world will be over."

PROPHETIC DREAMS

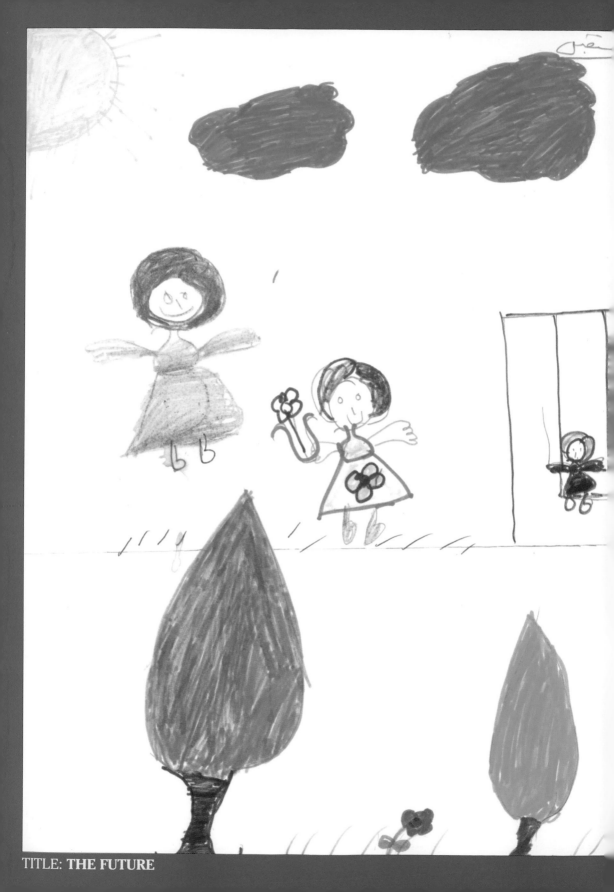

TITLE: **THE FUTURE**

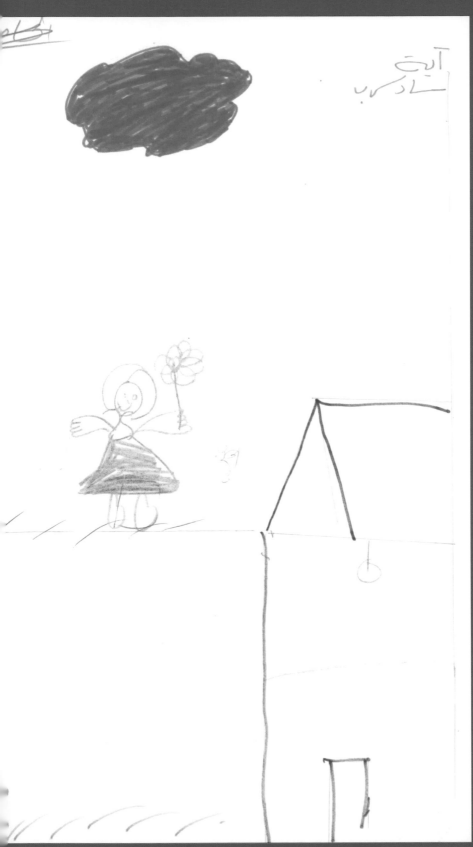

"In the future I want to be able to play by myself and with other children without being afraid of anything. I want to enjoy the sun and the clouds and swing in the air without a care in the world."

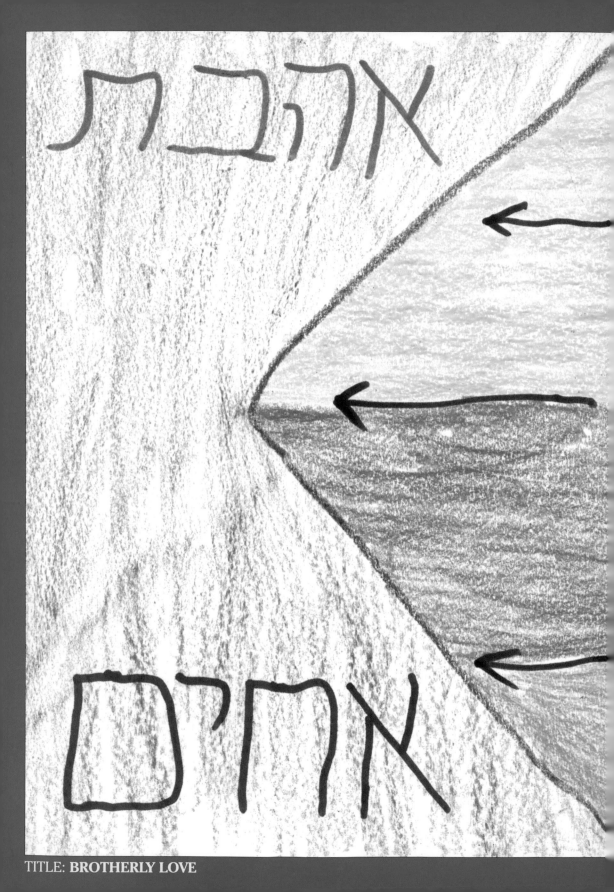

TITLE: **BROTHERLY LOVE**

שלום

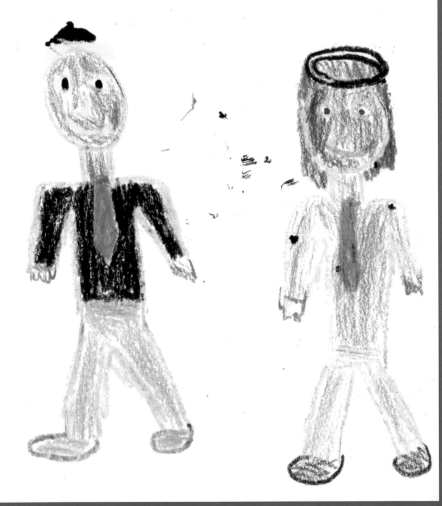

"I think that in the future there will be peace between Arabs and Israelis, and that is also what I want. I believe that we have to sit down and talk with each other and that by understanding each other we will be able to make a peace treaty that will last."

YISRAEL, AGE 12, ISRAELI

عمل الطالب :- محمد حنوظا
الصف :- الخامس زب

TITLE: **HAPPINESS**

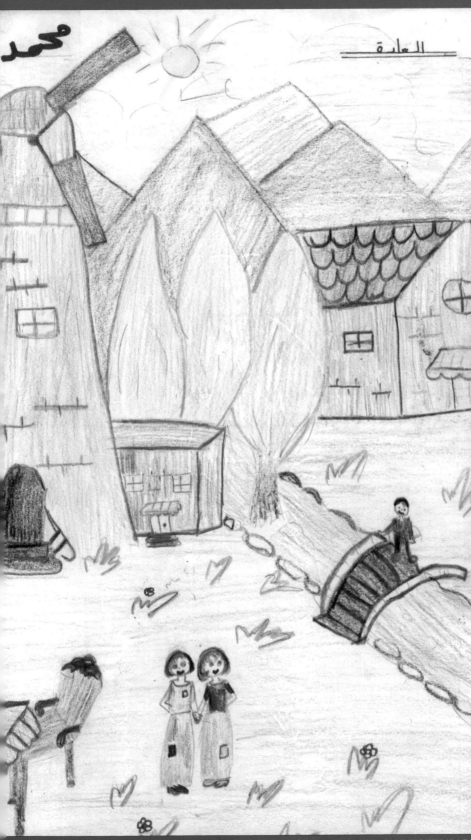

"*Eventually we will have peace in the land. We will be able to live with our neighbors and friends. The only bridges we will need are those that cross the streams between each other's houses.*"

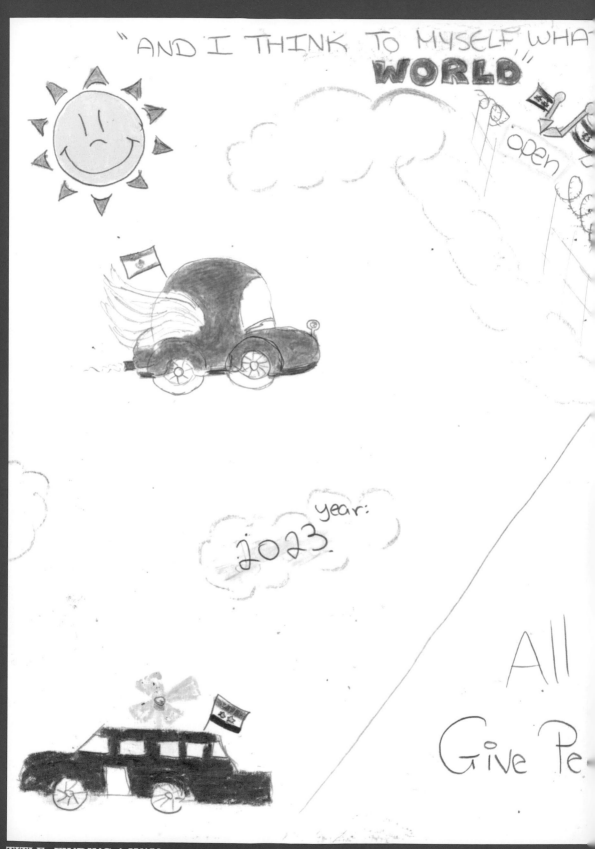

TITLE: FINDING A WAY

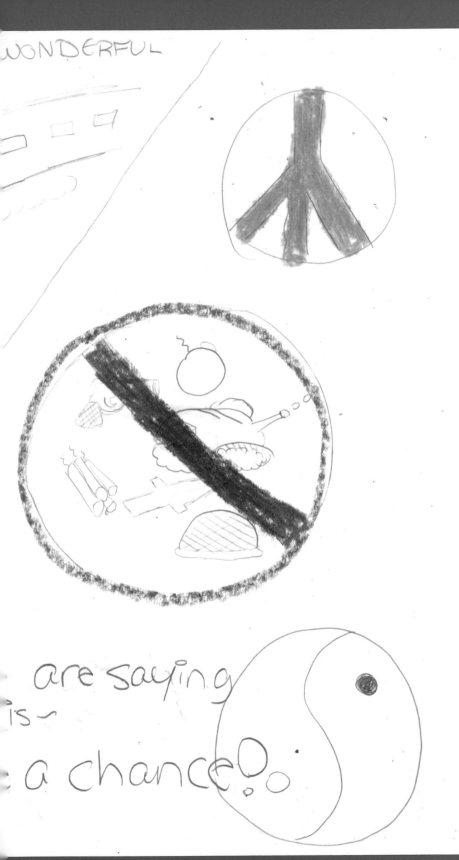

"*It would be wonderful if one day we could visit each other. This can only happen when there is no fear or worry. This can only happen when Israelis and Palestinians can travel the roads freely. This can only happen when there is peace.*"

WONDERFUL

are saying

is~

a chance

MAYA, AGE 11, ISRAELI

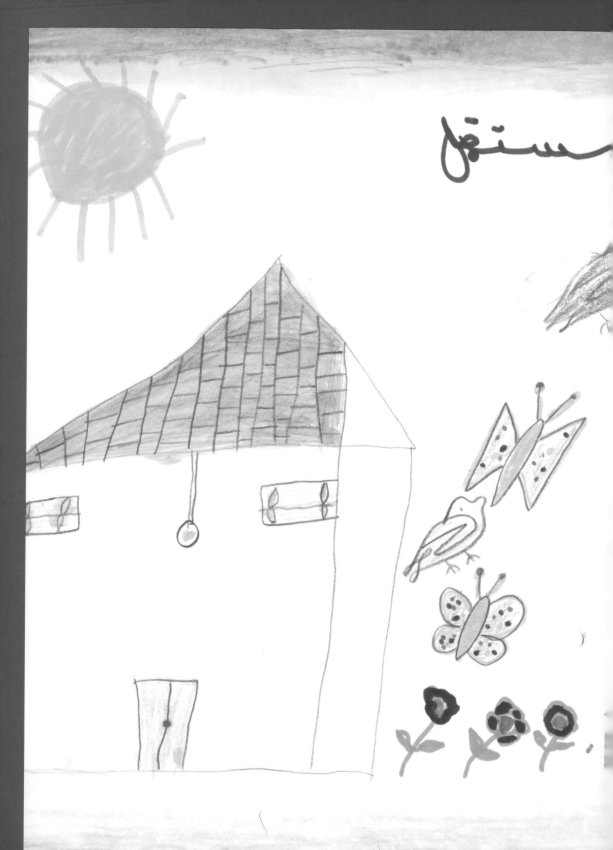

TITLE: **TOWARDS THE FUTURE**

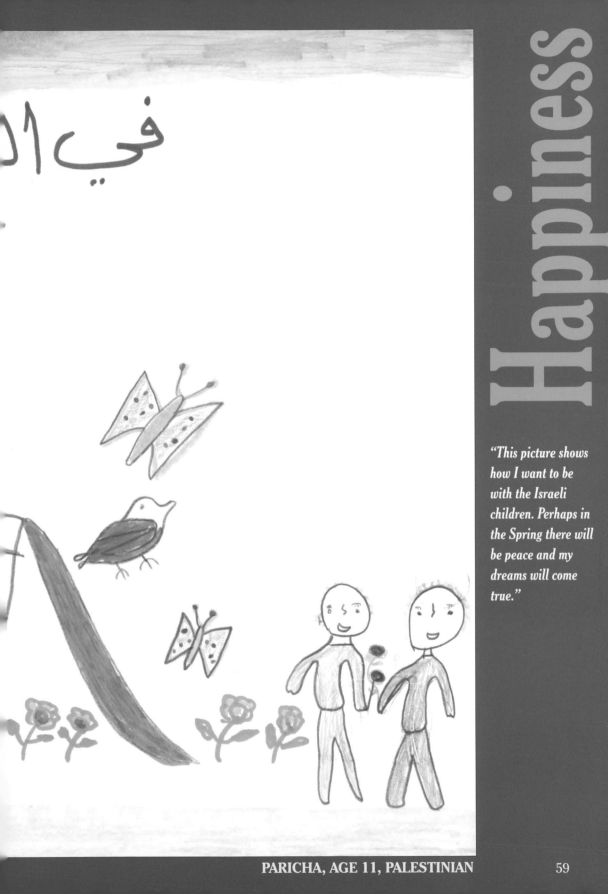

في ال

"This picture shows how I want to be with the Israeli children. Perhaps in the Spring there will be peace and my dreams will come true."

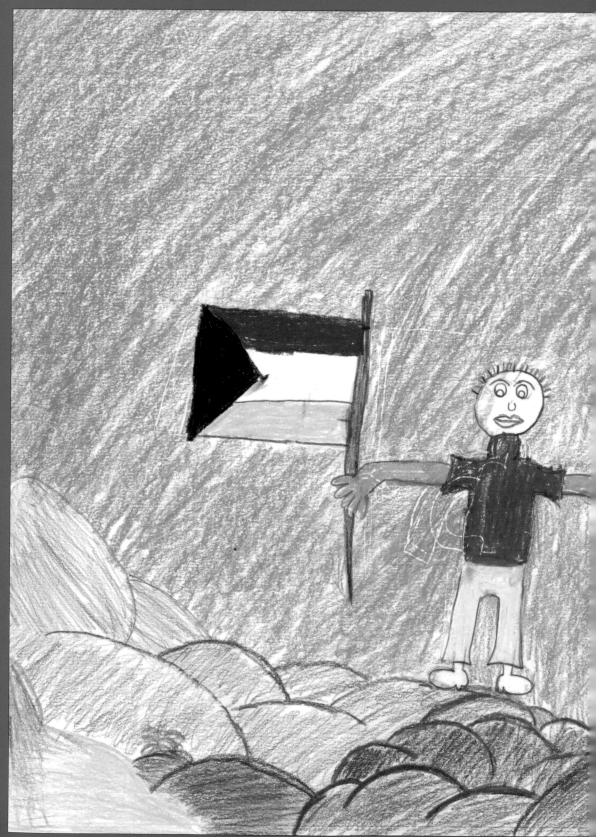

TITLE: **EACH THEIR OWN LAND**

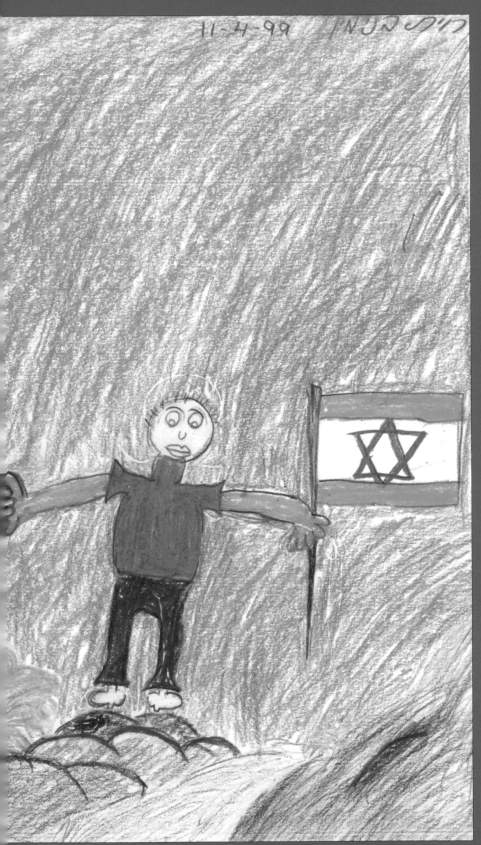

Self-confidence

"Israelis and Palestinians will have their own countries. They can accomplish this best by working together."

RAVIT, AGE 11, ISRAELI 61

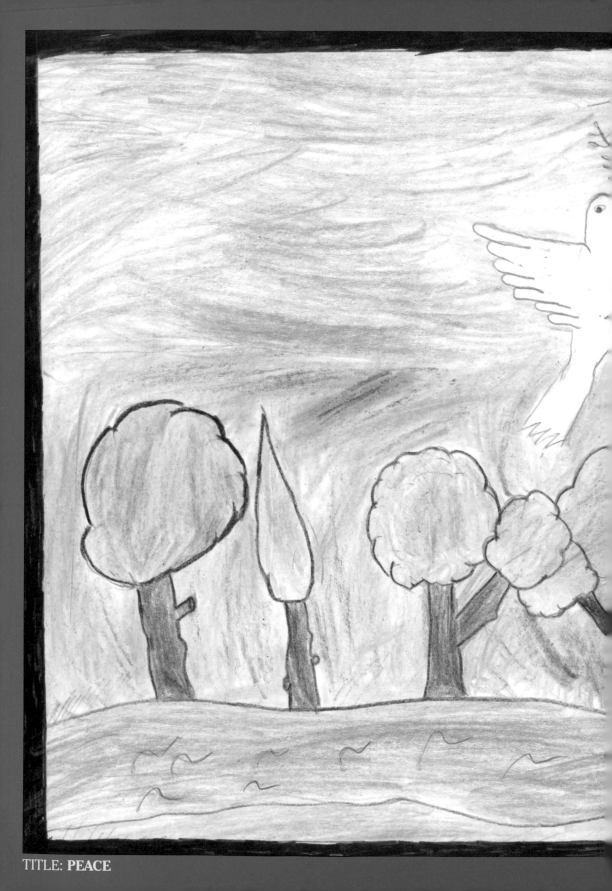

TITLE: **PEACE**

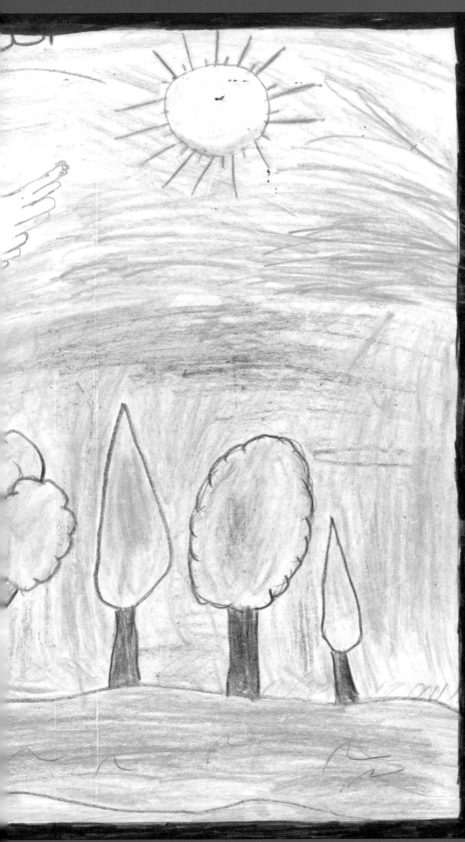

Growth

"*The future will bring peace and we will live in harmony. Everything will bloom and grow and everyone will care for each other.*"

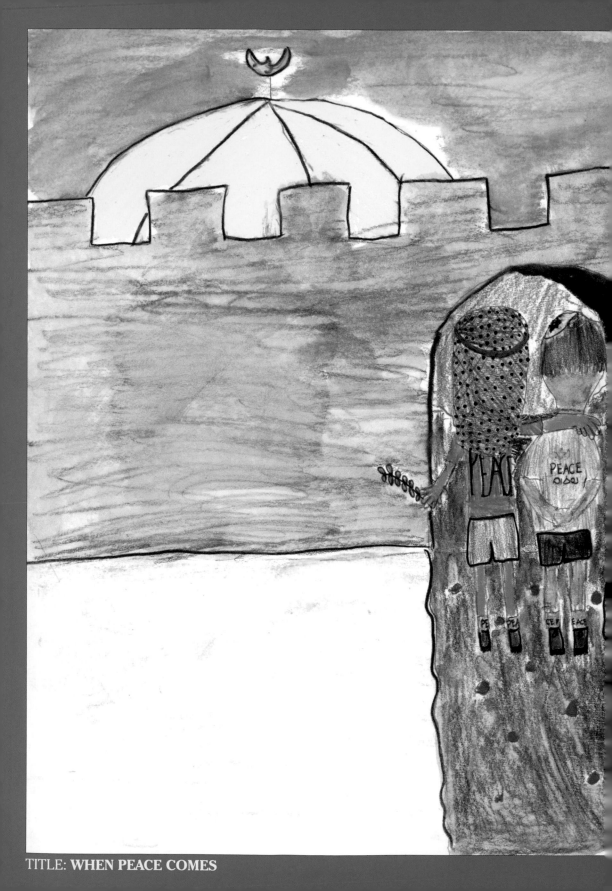

TITLE: **WHEN PEACE COMES**

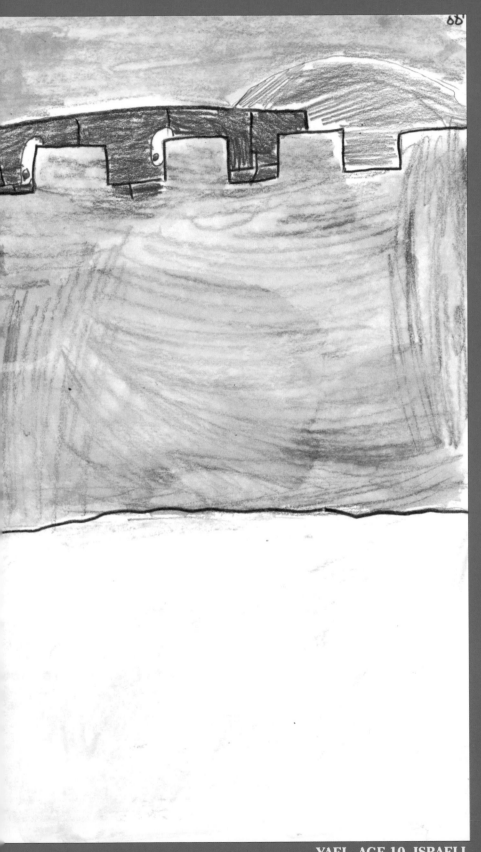

"In the future,
Jews and Arabs
will be able to pray
in Jerusalem and
respect each other.
Peace will open the
gates of Jerusalem
to everyone."

YAEL, AGE 10, ISRAELI

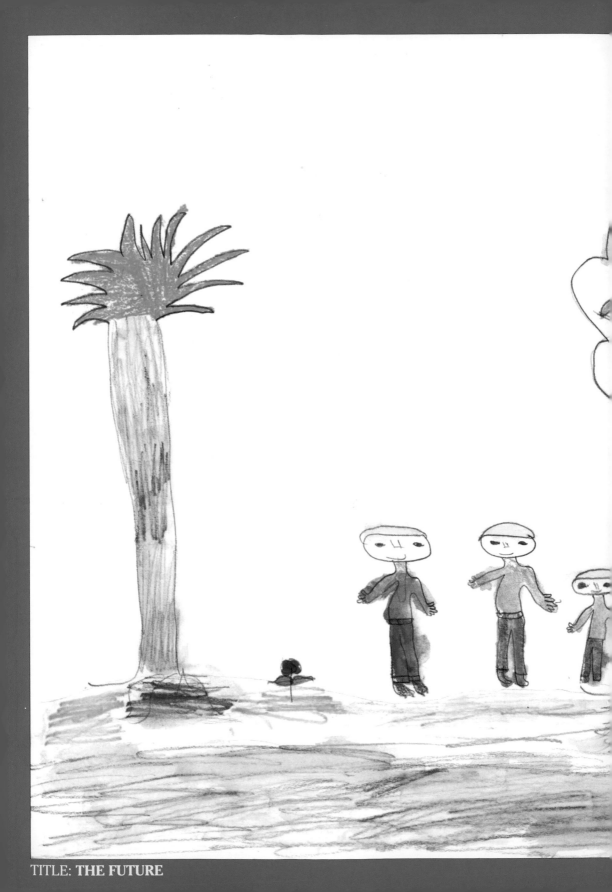

TITLE: **THE FUTURE**

المستقبل

"We can live in peace but this can only happen without wars. Once we stop thinking of how we can win wars we will begin to think how we can make peace."

ROKYAH, AGE 9, PALESTINIAN

67

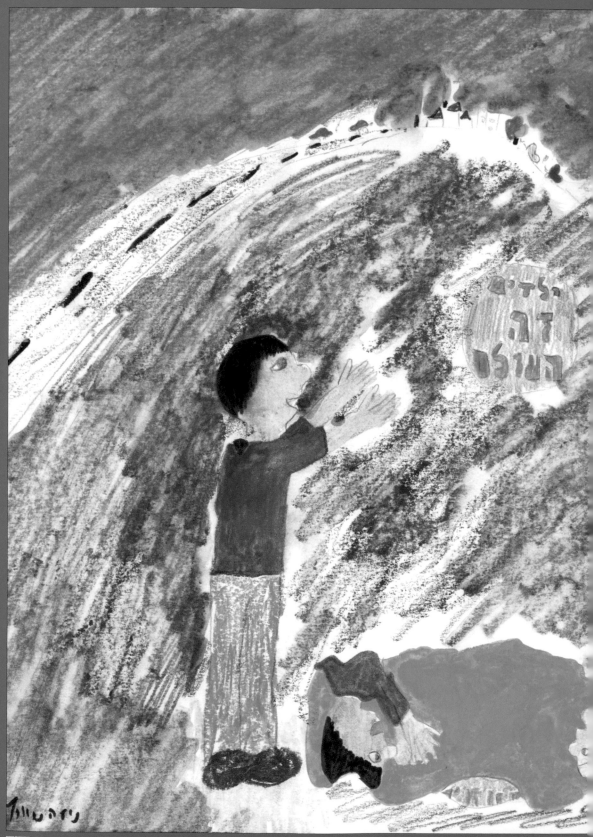

TITLE: **CHILDREN ARE THE WORLD**

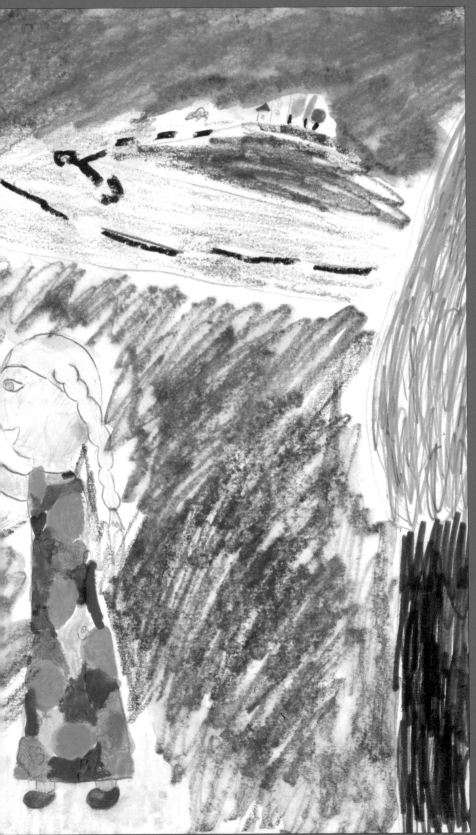

"The future must let peace survive. How? By having the parents learn from their children how to live in peace. If Israelis and Palestinians meet face-to-face then perhaps there will be less fear between us. After all, the Palestinians seem to fear us and we seem to fear them. Perhaps the contact between children can break this chain of fear."

NOA, AGE 11, ISRAELI

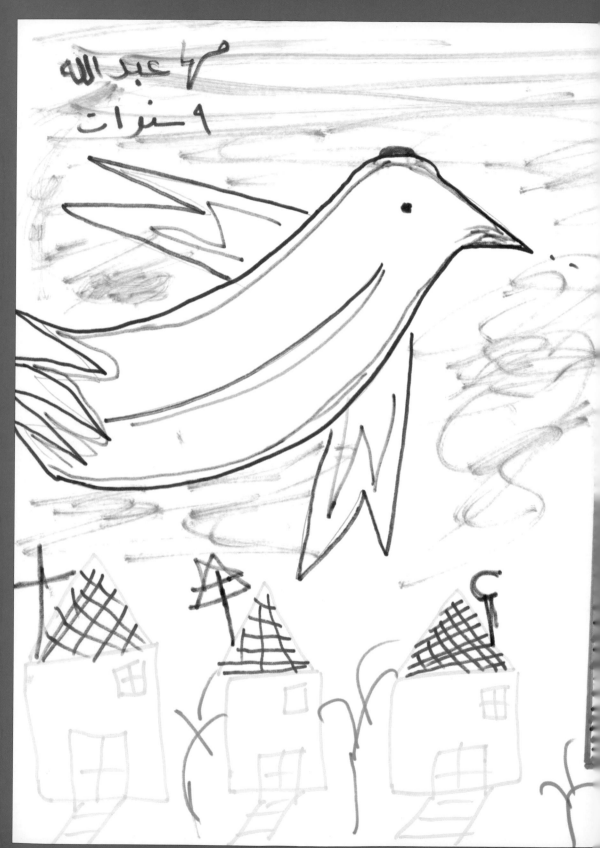

TITLE: **EDUCATION+HEALTH+SECURITY = PEACE**

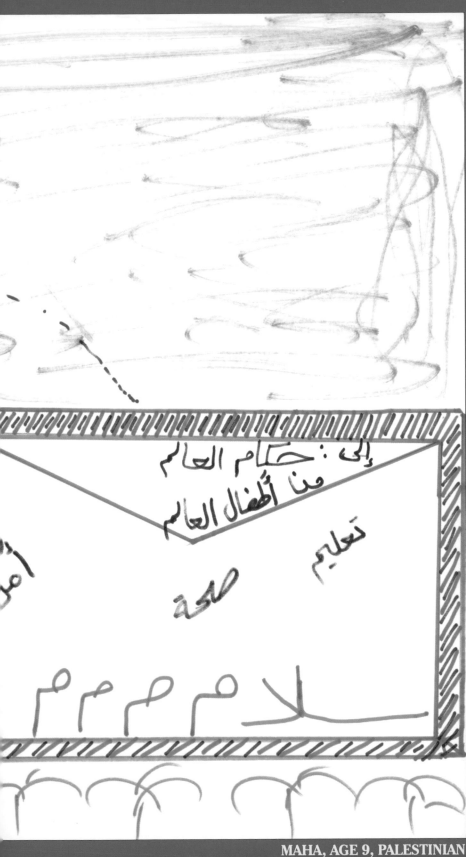

"I am tired of being scared and afraid for my parents, brothers and friends."

"I want to have a life without fear. This is what I wish for all the children of the world."

MAHA, AGE 9, PALESTINIAN

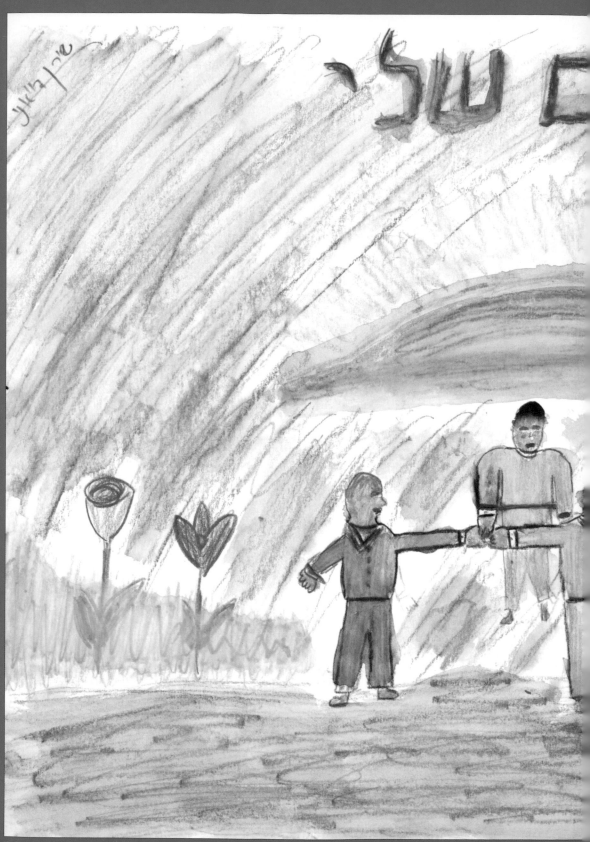

TITLE: **BEFORE THE PEACE/AFTER THE PEACE**

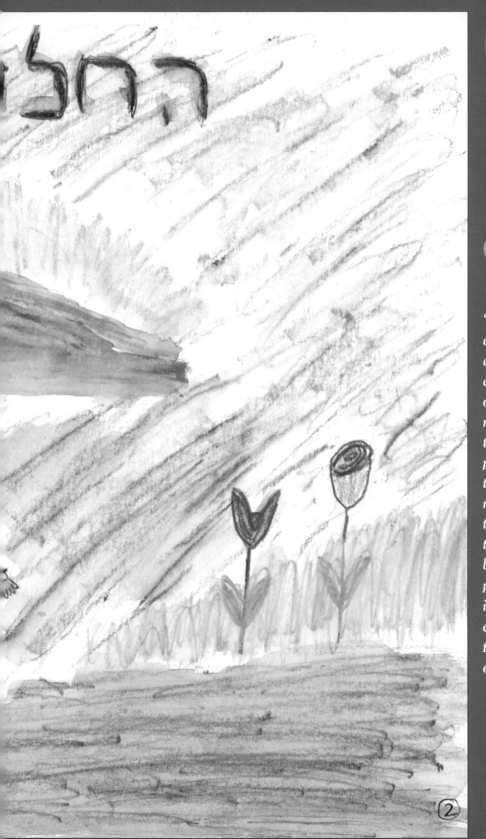

"Whenever there is an incident or an act of violence it changes the feelings of everyone, there is more hate. When there are pictures of people dying on television I prefer not to watch. I want there to be peace. I think it will happen, but not a complete peace. Even if peace is not complete, children will be able to play with each other."

TITLE: **IN THE FUTURE I WILL BE A TEACHER**

"I want peace in Palestine. In this way my country can grow and become great so that other countries will learn from us. In order to help my country reach this goal I will study hard and become a great and clever student so that when I am grown I will bring honor to my country and to the world."

سمر نجيب

SAHAR, AGE 11, PALESTINIAN

75

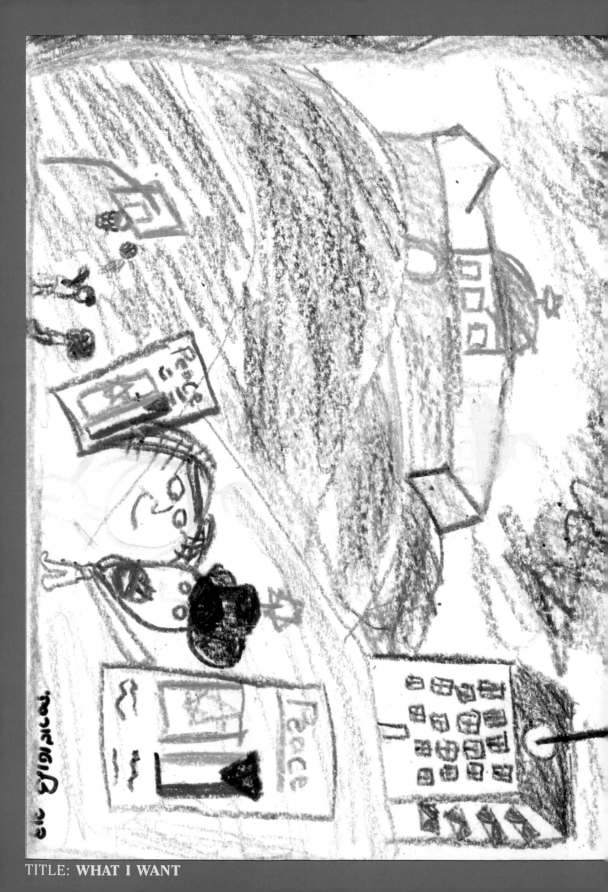

TITLE: **WHAT I WANT**

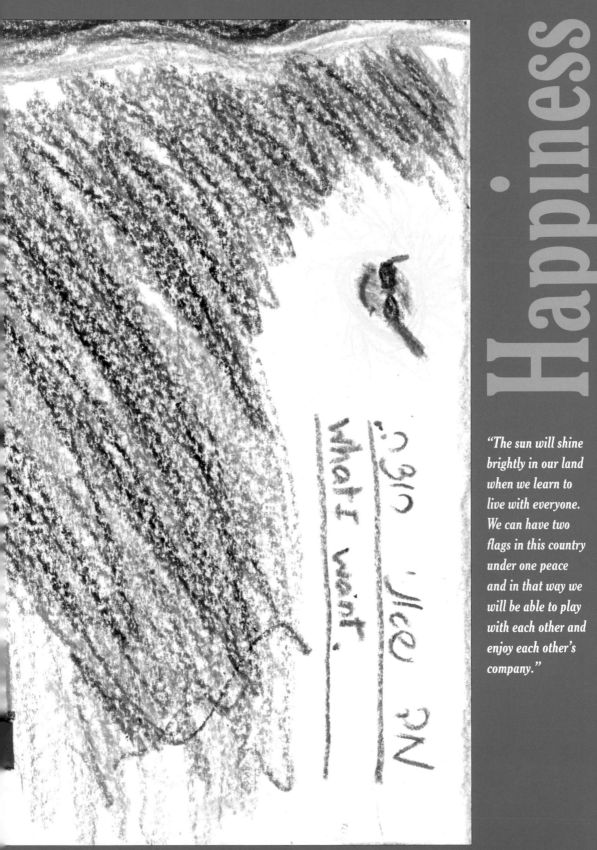

"The sun will shine brightly in our land when we learn to live with everyone. We can have two flags in this country under one peace and in that way we will be able to play with each other and enjoy each other's company."

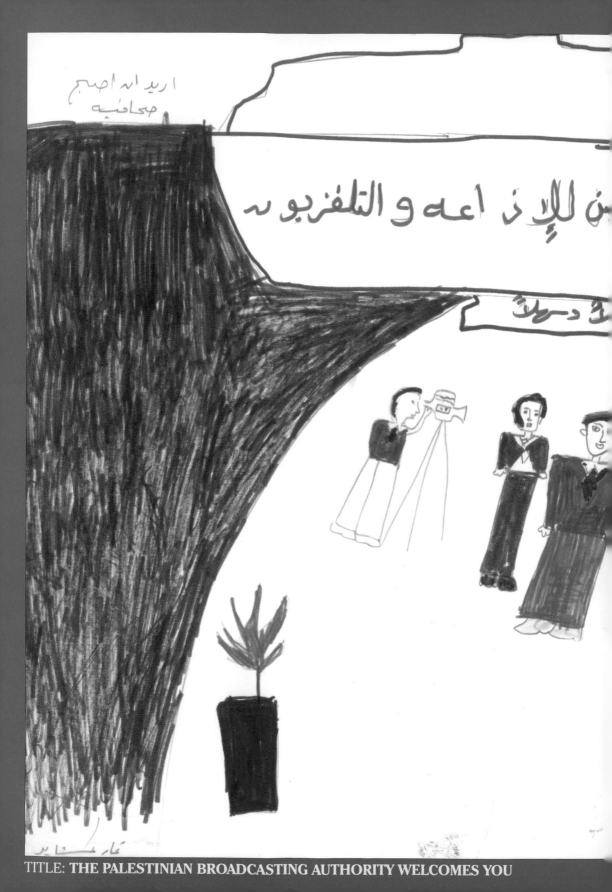

TITLE: **THE PALESTINIAN BROADCASTING AUTHORITY WELCOMES YOU**

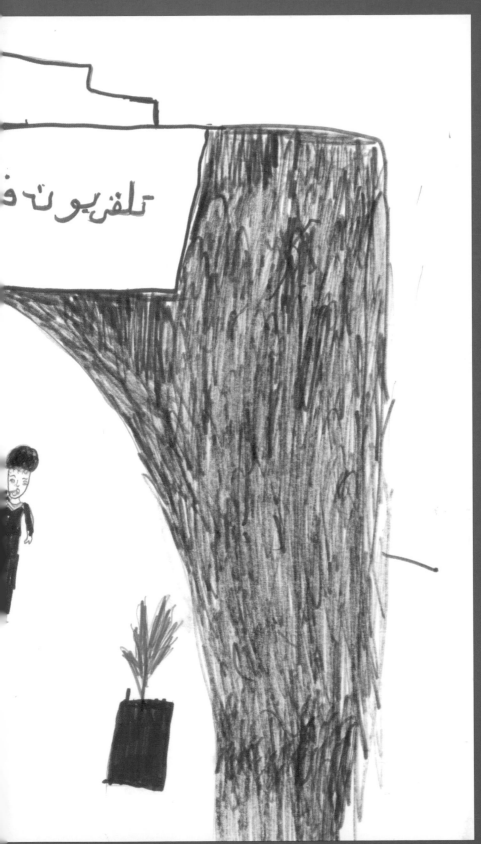

ت ل ف ز ي و ن ف

"I aspire to be a journalist in the future. I would like the Palestinian people to have their own shows and programs on television. This can happen if we have peace."

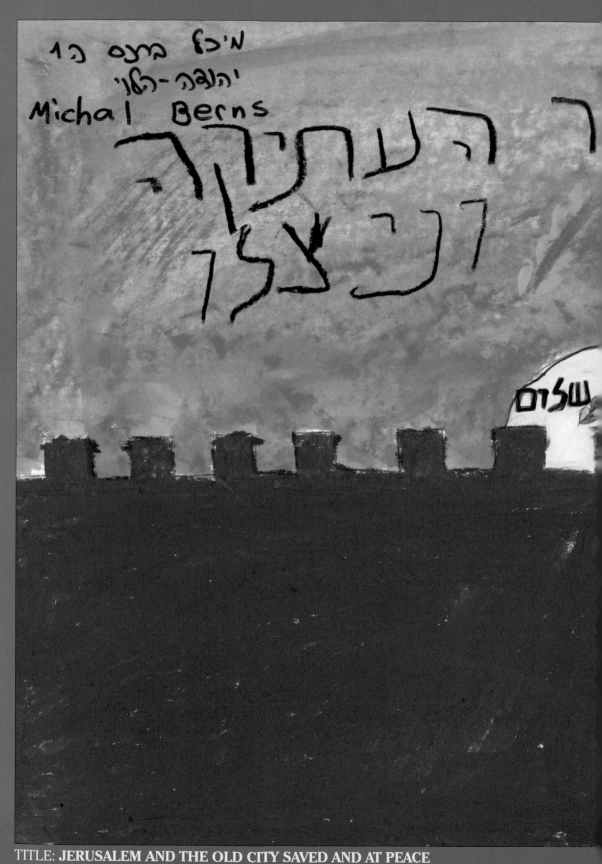

TITLE: **JERUSALEM AND THE OLD CITY SAVED AND AT PEACE**

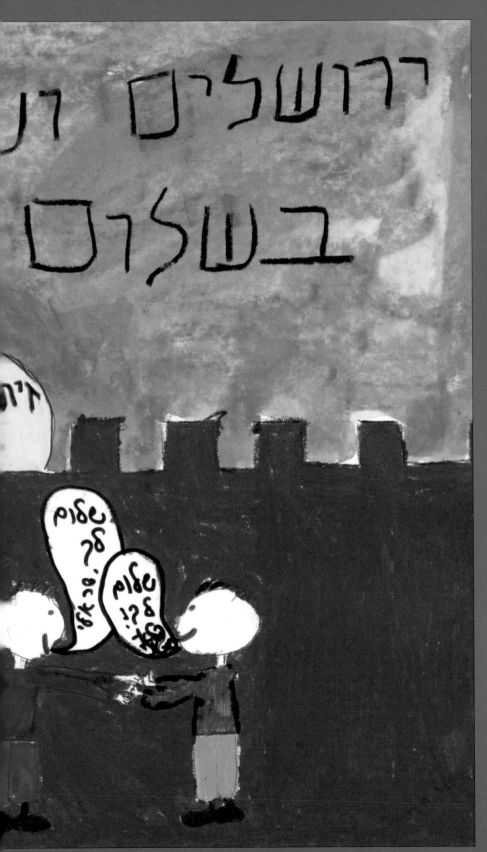

Brotherhood

"*I don't want to think about the bad things that happened. I only want to think about the good things that will happen. That's why I don't watch the news on television anymore. I think that in the future the Old City will belong to both Jews and Arabs since we will be friends.*"

MICHAL, AGE 11, ISRAELI

81

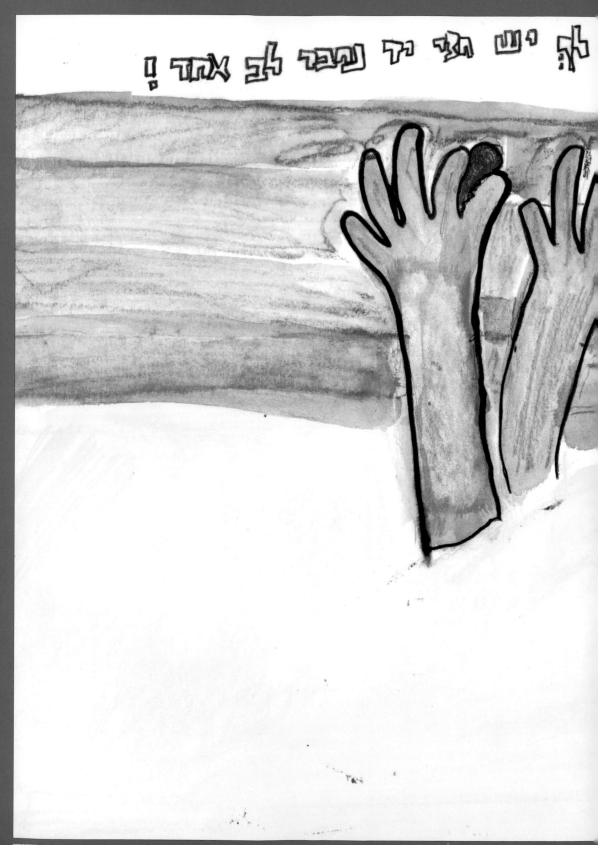

לי יש חצי יד ולכבר לי אחד !

TITLE: **I HAVE HALF, YOU HAVE HALF – TOGETHER WE CAN UNITE A HEART**

"The whole world can be without wars. If we share the land there will be no war."

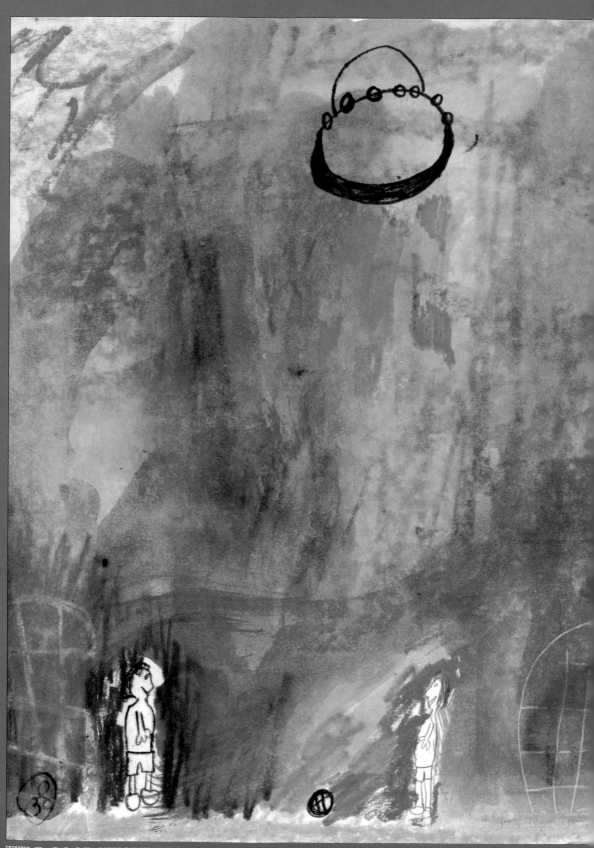

TITLE: **GOOD NEIGHBORS**

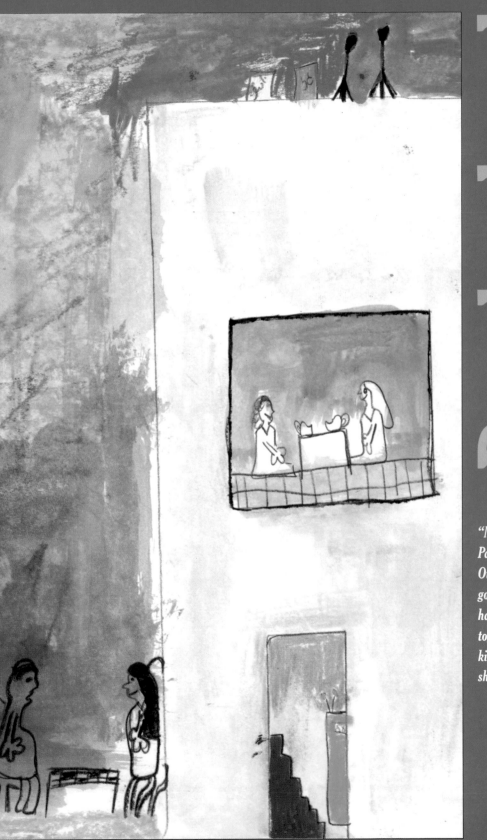

"My father has a Palestinian friend. Our families are good friends. We have learned to live together. This is the kind of future we should all have."

אמ'כה

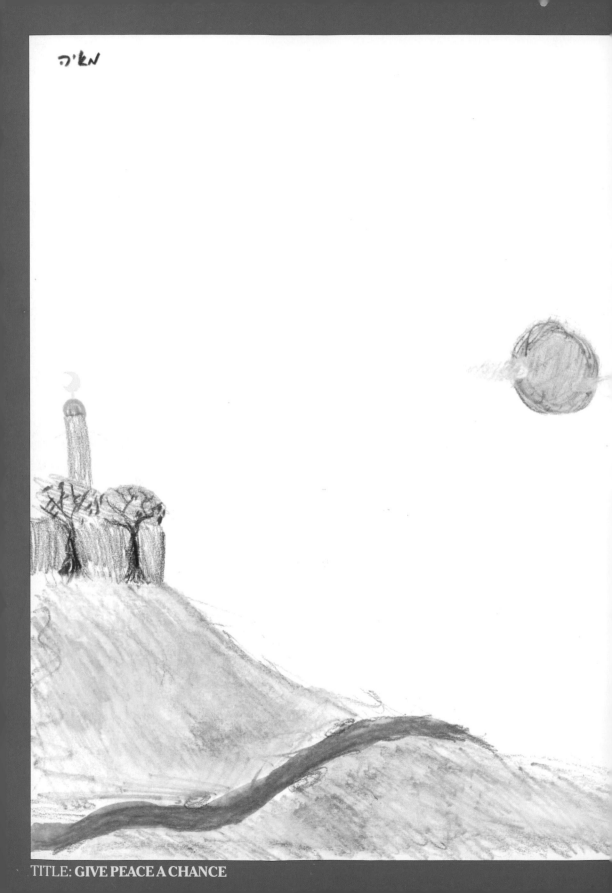

TITLE: **GIVE PEACE A CHANCE**

"*Everyone is always saying that you must have patience, you must be willing to give in, you must be willing to help others, to protect others, but no one is willing to be the first. I think that only if we accept one another will all the wonderful things we want finally happen. It takes time and effort, but in the end, the results are worth it. Sometimes it seems as though there is a clear road to peace, and at other times, it seems like peace is only a dream. But if we believe and we work at it — PEACE WILL HAPPEN!*"

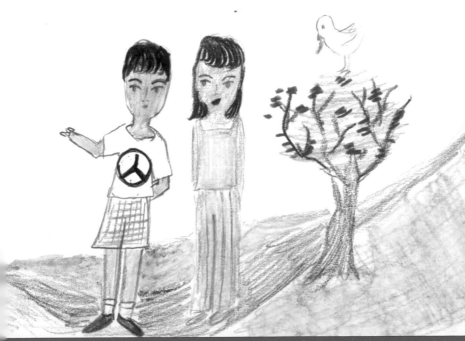

NOA, AGE 12, ISRAELI